COLLECTING THE IMAGINATION

HARRY RANSOM
CENTER

PUBLISHED FROM THE COLLECTIONS OF THE HRC

*Harry Ransom
Humanities Research Center
Imprint Series*

Stuart Gilbert, *Reflections on James Joyce: Stuart Gilbert's Paris Journal*, ed. Thomas F. Staley and Randolph Lewis. 1993

Ezra Pound, *The Letters of Ezra Pound to Alice Corbin Henderson*, ed. Ira B. Nadel. 1993

Nikolay Punin, *Nikolay Punin: Diaries, 1904–1953*, ed. Sidney Monas and Jennifer Greene Krupala, trans. Jennifer Greene Krupala. 1999

Aldous Huxley, *Now More Than Ever*, ed. David Bradshaw and James Sexton. 2000

Stanley Burnshaw, *The Collected Poems and Selected Prose.* 2000

Laura Wilson, *Avedon at Work: In the American West.* 2003

Kurt Heinzelman, ed., *The Covarrubias Circle: Nickolas Muray's Collection of Twentieth-Century Mexican Art.* 2004

Sanora Babb, photographs by Dorothy Babb, *Workers of the Western Valleys*, ed. Douglas Wixon. 2007

William Goyen, *Goyen: Autobiographical Essays, Notebooks, Evocations, Interviews*, ed. Reginald Gibbons. 2007

COLLECTING THE IMAGINATION

THE FIRST FIFTY YEARS OF THE RANSOM CENTER

EDITED BY
Megan Barnard

INTRODUCTION BY
Thomas F. Staley, Director

University of Texas Press · AUSTIN

John B. Thomas, III

Cathy Henderson

FRONTISPIECE
The signatures of writers and artists whose materials are housed at the Ransom Center are etched into the glass surrounding the entrance doors. Photograph by Hester + Hardaway Photographers.

PAGE VIII
Exterior view of etched glass surrounding the Ransom Center's north atrium. Photograph by Hester + Hardaway Photographers.

PAGE XXIV
Exterior view of the Ransom Center's south atrium. Photograph by Hester + Hardaway Photographers.

Requests for permission to reproduce material from this work should be sent to:
PERMISSIONS
UNIVERSITY OF TEXAS PRESS
P.O. BOX 7819
AUSTIN, TX 78713–7819
WWW.UTEXAS.EDU/UTPRESS/ABOUT/BPERMISSION.HTML

⊗ The paper used in this book meets the minimum requirements of
ANSI/NISO Z39.48–1992 (R1997) (Permanence of Paper).

LIBRARY OF CONGRESS CATALOGING-IN-PUBLICATION DATA

Collecting the imagination : the first fifty years of the Ransom Center / edited by Megan Barnard. — 1st ed.
 p. cm. — (Harry Ransom Humanities Research Center imprint series)
Includes bibliographical references and index.
ISBN-13: 978-0-292-71489-2 (cl. : alk. paper)
ISBN-10: 0-292-71489-0
1. Harry Ransom Humanities Research Center—History. 2. Research libraries—Texas—Austin—History. I. Barnard, Megan, 1978– II. Series.
Z733.H29C65 2007
027.7764′31—dc22 2006017544

CONTENTS

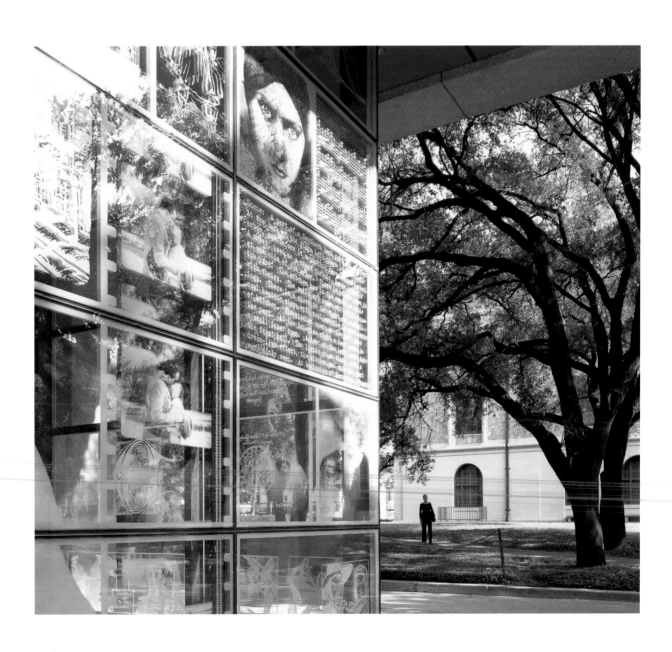

This volume celebrates the first half century of the Harry Ransom Humanities Research Center. Beginning with the early years of the University of Texas, when the Center's first collections were acquired, it traces the Center's growth from conception and creation to its present stature as one of America's preeminent institutions for research and learning in the arts and humanities. Fifty years is a short time on history's clock, especially when measuring the legacies of libraries and museums. Such histories span centuries, from the founding of the library in Alexandria to the relatively recent establishment of the great libraries of North America. Then and now, these institutions were created to illuminate cultures and record civilizations. A library is built upon a fundamental optimism, a belief that it is essential to know the past in order to understand the present and to better anticipate the future.

As this story unfolds, it reveals a vision that over the years nurtured the Ransom Center in its gestation, growth, and rise to prominence. The Center's international renown should not dim the fact that much of its success is owed to the University of Texas, whose leaders believed that the strength of its libraries and faculty would distinguish it from other universities. Since the middle of the last century, Harry Ransom and his successors have been keenly aware that it was the uniqueness of the Center's collections that made it different from other academic libraries. The Center has benefited greatly from the esteem in which it has been held by University leaders and from their critical support for major acquisitions. During Lorene Rogers's presidency, the Gutenberg Bible was acquired. Peter Flawn supported the acquisition of Henri Matisse's *Jazz,* one of the finest artist's books of the twentieth century. During William Cunningham's tenure, the Pforzheimer collection came to Texas. Larry Faulkner led the purchase of the Woodward and Bernstein Watergate papers. In addition to these major acquisitions,

there is what one observer described as the Center's "awesome holdings, which for some time have exerted something like a gravitational pull on other contemporary authors." For all its magnetic "pull" in the world of libraries, the Center has remained deeply committed to its vital role in the intellectual and cultural life of the University, and—like the University—its mission serves a world beyond its doors. Jorge Luis Borges once called a library a door in time. The narrative that follows affirms that the Ransom Center has indeed been a door leading to knowledge and discovery not only in Texas but throughout the world, and even more so since the emergence of the internet.

Libraries and museums, perhaps in a way different from other institutions, reflect the values of the culture that creates them, and the Ransom Center is no exception. The Center still owes much of its character to what Harry Ransom, its founder, called—in his December 1956 speech to the Philosophical Society of Texas—a vision at once "historic and prophetic." In the speech, which is reprinted in its entirety following this introduction, Ransom praised the early Texans who looked back to the great libraries of the past and forward to the future cultural needs of their citizens. Although such a historical formulation was hardly unique, it was a theme that Ransom seized upon when in 1957 he began to transform the University's relatively small collection of rare books and manuscripts into the research center that would eventually bear his name. This Janus-like vision was an ideal one for building a great library. It valued and celebrated the past while simultaneously looking with a vigorous and enthusiastic eye to the future. Such an idea was the perfect engine to drive his ambitions. Ransom, like Larry Faulkner fifty years later, if in a very different way, recognized this fusion of past and present for the entire University while giving it a uniquely Texan perspective.

While part of a great university, it is the Center's own growth and achievement in the world of scholarship and learning that is the focus of this book. In 1990, not long after I joined the Ransom Center, I noted in the foreword of our *Guide to the Harry Ransom Humanities Research Center* that the Center's rapid development "has paralleled the pace of the age in which it came into existence." This comment still strikes me as relevant. The growth and maturity of the Ransom Center has moved, and continues to move, at a remarkable pace, as this written history makes clear.

Besides telling the story of an important library, this narrative also documents the growth of the Center's collections, the origins and evolution of its renowned conservation department, the stature of its manuscript and book cataloging departments, and the increasingly impressive reputation of its photography department. It recounts the

remarkable development of expanded exhibitions and public programs following the 2003 reconstruction of the building, with its addition of spacious galleries, a state-of-the-art auditorium, a handsome reading room, and other welcoming public spaces.

Less immediately apparent but more far-reaching has been the Center's integration of technology with its traditional strengths. Not since Gutenberg's invention of movable type has there been as profound a revolution in the method of information exchange. Technological developments have transformed the library world, and constituents far beyond the walls of the Ransom Center can now access information about the Center and its collections through the internet. Millions of people visit the Center's website to view digitized materials in our online exhibitions and to study online finding aids, catalogs, and descriptions of our collections. At the Ransom Center, digital culture and the culture and history of the book work together to provide information and, more importantly, to integrate and give coherence to knowledge. As the pages of this narrative relate, the Center's staff not only participates in the information revolution, it helps direct its course.

Yet with all the great opportunities that have come with digitization, the virtual world, and changing technologies, at the heart of the Center's concern remains the original work. As the critic Walter Benjamin famously noted, "Even the most perfect reproduction of a work of art is lacking in one element: its presence in time and space, its unique existence at the place where it happens to be." The "original" artifact, according to Benjamin, "is the prerequisite to the concept of authenticity."[1] However beautifully reproduced or technically perfect a copy may be, the aura of the authentic artifact, its existence in history, is maintained only by the original. It is this object—whether it be a leaf of manuscript, a photograph, a painting, or the original book that reveals its own history and provenance through paper, type, and annotations—that opens the door to a more complete study of the work and of the creative process itself. The study of these original materials gets us closer to what Alfred Kazin once called "the marginal suggestiveness which in a great writer always indicates those unspoken reserves, that silent assessment of life, that can be heard below and beyond the slow marshalling of thought."[2] Students who come to the Center are able to hold in their own hands the very works that passed from the hands of the great figures they are studying in their courses. They can examine the succession of drafts that led to a published work—the false starts, the scratch outs and rewrites that are the relics of an author digging for the right words. As one critic has observed, the completion of this journey marks the end of the artist's private creative process and the beginning of the work's public life.

Thomas F. Staley,
Director of the Harry Ransom Center

Students working at the Ransom Center become engaged with works, with writers, and with artists on an intimate level, perhaps inspiring a deeper interest in and understanding of culture and art. For example, when reading James Joyce's *Ulysses,* students can see the final page proofs of the work, the last touches Joyce made, struggling with his terrible vision and compulsive revision of nearly every page, before he bundled up his fifth set of proofs and sent it from his Paris apartment to his printer in Dijon. In this form, one can feel and surely understand the almost obsessive care and driven energy of the artist. Like all literary manuscripts, these materials have, as Philip Larkin once noted, two kinds of value: the magical and the meaningful. Beyond the thrill of discovery is the shock of recognition in the student as he or she engages with the authentic object and comes to understand more fully the creative process, the topography, if you will, of the writer's imagination. In these circumstances, one could say that the object has indeed a life of its own.

The pages in this volume relate the story of an American institution. This narrative is divided into four parts, spanning the chronology of the Center. Each of these parts, however, explores different aspects of the Center's growth, based on the relevant issues of the time. The nascent growth of the University's library and Rare Books Collection is covered by John Thomas. Cathy Henderson's section details the institutionalization of the Center and Harry Ransom's spectacular acquisition program, which culminated in the Center's inclusion in Anthony Hobson's book *Great Libraries.* Richard Oram's chapter treats the growing pains and controversies the Center faced as it became more organized and reached maturity as an institution. Megan Barnard's chapter relates the sustained growth of collections into the twenty-first century as well as the expanding role of the Center in higher education and its far more visible public role. Each of these chapters reveals the evolution of an institution that has absorbed the values and philosophy of the past to better understand the present and prepare for the future. The reader will observe here the threads that will lead the Ransom Center into the next chapter of a great story.

A fitting endorsement of the Center came from British writer Simon Winchester, who in 2005 opened the Texas Book Festival with a reading at the Center. In an interview with a student reporter, Winchester remarked upon how seriously Americans regard writers. "In a way," he said, standing in front of the Center and gazing up at the remarkable images etched in glass, "this building we're sitting outside of symbolizes everything I'm saying about America."

The Ransom Center is a wonderful place. As this volume makes clear, the Center has, throughout its fifty years, helped define the aspirations

of this great University. As we celebrate our past, we are eager to ponder and engage the future.

NOTES

1. Benjamin, "Work of Art," 222.
2. Kazin, *On Native Grounds*.

PRELUDE

"THE COLLECTION OF KNOWLEDGE IN TEXAS"

Harry Huntt Ransom

The following essay was presented at the annual meeting of the Philosophical Society of Texas in Austin on December 8, 1956.

The underpinnings of this discussion are certain assumptions or beliefs which must be stated bluntly at the start:

First, that it is the obligation of any cultural entity like Texas to keep its intellectual purposes clear and to keep up with its intellectual obligations. Second, that the essential tradition of Texas is based upon human values easy to recognize and hard to realize. Third, that Texans today, recognizing these values, stand ready to maintain them realistically. Fourth, that Texas, which now ranks sixth or seventh in private income among the forty-eight states, has the material power to fulfill its intellectual obligations in practical ways. Finally, that this Society is a legitimate company in which to make suggestions for the intellectual good of the state.

For these reasons I will propose tonight that there be established somewhere in Texas—let's say in the capital city—a center of our cultural compass—a research center to be the Bibliothèque Nationale of the only state that started out as an independent nation.

The sense of what I have to say goes back to the first manifesto of the Philosophical Society. The intention of this discussion, however, looks forward to the immediate and distant future of Texas. You will remember that the main business of this organization was originally described as "the collection and diffusion of knowledge." The Society's earliest memorial puts its program of action in these terms: "Texas, having fought the battles of liberty . . . now thrown upon her internal resources for the permanence of her institutions, moral and political, calls upon all persons to use all their efforts for the increase and diffusion of knowledge and sound information."

Collection of knowledge, considered as a social responsibility of the state—and that is how the Philosophical Society in 1837 did consider it—is a very complex process. I intend to treat a single phase of the process, and to treat that phase quite simply. But whenever groups of men—societies, political associations, states, and nations—have set about to keep their minds alive by getting their minds ready to meet the future, they have paid some attention to history. Before making a brash attempt to paraphrase the Society's initial definition of its business by suggesting a new focal point of our intellectual resources I shall therefore recite a brief prologue, more or less historical.

Knowledge can be collected in many ways, the most obvious of which is the collection of knowledgeable people. Our learned teaching faculties and our inventive research staffs do not represent better collecting of this kind than did certain ancient kingdoms. A lively trade in minds was partly responsible for classical and medieval wisdom. When seers were not indigenous, they were often imported. Some were lured to a metropolis because it had a reputation for cherishing knowledge; some were literally kidnapped; some were brought to court by worldly blandishments that make industry's recent raids on college faculties look puny and penny-minded. Many an emperor accomplished more (and, indeed, attained a more nearly permanent glory) by capturing wise men than by winning battles, more by cultivating philosophers than by cutting down political enemies. But trade in living minds—scholars on the hoof—could not suffice for the development of Western civilization.

It is an obvious law of nature that collections of living men, however wise, constitute highly perishable collections of knowledge. Enlightened human minds almost invariably outmode themselves by encouraging continual search for new knowledge, new synthesis. Furthermore, no matter how great their undertaking or how vast their accomplishment, all knowing men are sooner or later overtaken by death. So the collection of permanent records has always been essential to civilization.

In looking far backward, one is tempted to speculate upon the motives which originally brought men to collect the tokens of man's experience and his imagination, his discovery and his calculation. Can the drive which brought on Europe's periodic seasons of vast intellectual hunger be explained by grand maxims like "Knowledge is power"? Should it be interpreted more idealistically: Collection of knowledge has always enlarged perspective, allowing men to see a little past the borders of their own experience? Or must the impulse be reduced to something just above the motives of the packrat: Collection helps collectors to endure life's inescapable moments of insecurity? No matter what the explanation, it was long ago that men determined to save man's records from oblivion. Whatever gave it force, that determination shaped our intellectual history. It still shapes our intellectual history.

To the unwitting, the process of getting knowledge together appears at times either lumbering or ludicrous. Yet unexpected increments have kept coming from apparently "useless" collections of knowledge; odd conglomerations of things or facts or ideas have often brought about profound public benefit or done historic service to the common weal. For example, a case of Pacific island birds' eggs contributed to the strategy of a great military campaign. Trays of ancient coins were used to revise our knowledge of ancient political chronology. In the nineteenth century a museum of human brains gave impetus to that wing of mental philosophy known today as experimental psychology. A collection of fossils provided new light for the assumptions of anthropology. Rare stamp albums are still the source of essential information about engraving methods. There was a time when a series of oil-well cores would have been considered a useless geological gatherum; yet the first extensive collection of such chunks of the lower world did great service to the oil industry, and later collections still serve it.

Admittedly some collecting looks foolish and may be so in fact. Only morbid curiosity seems to justify the preservation anywhere—much less in Austin, Texas—of miscellaneous locks of hair from the heads of statesmen like Napoleon and poets like Shelley. But memory of what even stranger collections than this have wrought in the past will make one hesitate to predict that this haircut museum will never, never contribute to learning.

Of all systematic collections of knowledge, those called libraries are most easily explained. An agreeable, if uncertain, chapter in this history is the account of the making of the library at Alexandria. Let me paraphrase one version of it: When Ptolemy Philadelphus, one of the kings of Alexandria, ruled, he attracted to himself knowledge and learned men. And he searched for books of wisdom and gave orders to have them brought to him. And he set apart for them libraries where they were to be collected. And he put in charge of them a man called Zumayra, the son of Murra, who was zealous in their collection and procurement, and Zumayra paid high prices for the provision of them. He asked Zumayra, saying, "Do you suppose that there are other books of wisdom on this earth which we do not have?" And Zumayra told him: "There are some books in China, India, Persia, . . . Babylon, and also among the Romans that we do not have." And the king was pleased, and told him to keep on collecting.

When that library in Alexandria went up in smoke, man's zeal for bringing together the record of human experience did not evaporate. At Rome, at Paris, in improbable places, from Ireland to obscure Oriental palaces, the zeal for preservation of knowledge asserted itself. Sometimes, of course, this zeal also spent itself. But in whatever places or at whatever time it died out, that dying out was never the end of it.

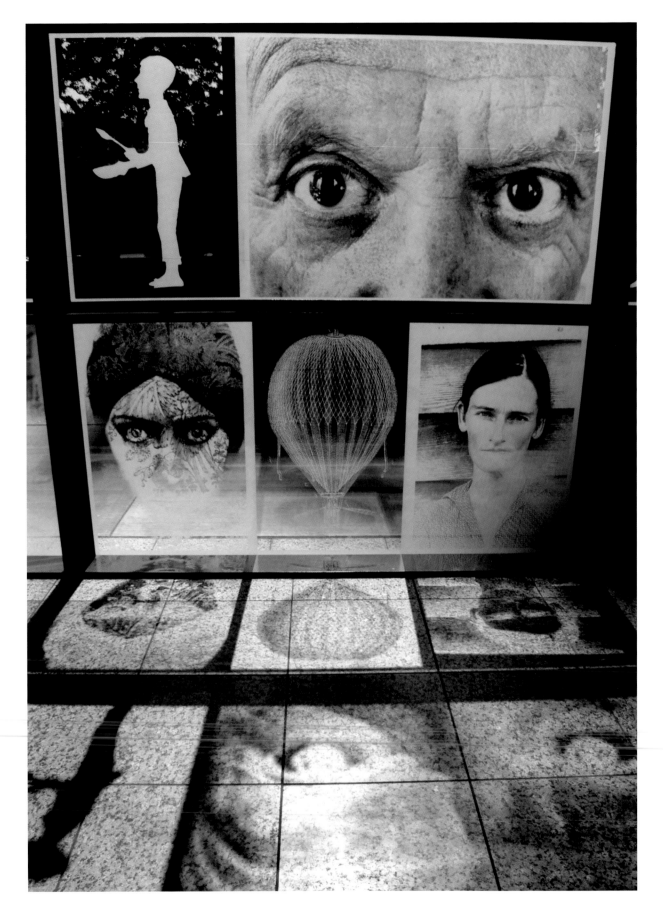

COLLECTING THE IMAGINATION

Some historians err, I think, in assuming that this concern about collecting the human record has been asserted only by well-organized societies, by sophisticated national or local groups with the high gloss of long cultivation. As a matter of fact, one is tempted to say that wherever there was a frontier in America, there was a counter-frontier, and that the main purpose of this counter-frontier was not only to help man grow or dig or catch or kill his living, but also to put this man in communication with the immemorial tradition of his kind and thereby to secure his descendants the benefits of the free mind.

Through the Constitution this counter-frontier spirit guaranteed the right of intellectual creation. This counter-frontier spirit founded in Philadelphia a Philosophical Society which is still busy with the advancement of knowledge. It was this same spirit which conceived the Library of Congress in terms bigger than the legislator's need to look up legal authorities. It was this spirit in the Philosophical Society of Texas which caused to be appointed among the Society's first officers a librarian.

Although to be effective, great collections of knowledge have always required public support, and although most great collections have pursued a policy of wide public benefit, the growing points of such intellectual enterprise have often been stimulated by individual collectors, purchasers, or donors. By such private intellectual enterprise, public imagination is fired; without it, public interest burns low.

To this principle of the relation of public interest to private exploit in collecting must be added an American corollary: in the United States, many of the great movers of intellectual material have been men of practical affairs. Henry Huntington, as the powerful investor in American railroads, developed a huge realism about business and society before the Huntington Library became a reality. His greatness lay in the sweep of his operations: nobody in the history of massing knowledge, before or since, has quite matched his enormous strides. Yet his formula was as simple as the combination of railroad interests: he collected collections.

Henry Clay Folger, whose perspective was different but whose final accomplishments were equally great, first attained eminence in the petroleum industry (he was chairman of the board of Standard Oil). His vision was specific, but not narrow: He dreamed the complete collection of Shakespeare—not only of the works but also of every conceivable subject Shakespearean—the life, times, sources, stage history, and criticism. It is an interesting commentary on the permeative qualities of collected knowledge that today the library in Washington which bears Folger's name is a center for the study of early American civilization. (Not even the wildest zealots who live on theories that Shakespeare did not write Shakespeare have yet suggested that Shakespeare was an American.)

From 1837 to 1856, the scriptorium, the bibliotheca of Western tradition which had become well established in our culture was transported

OPPOSITE PAGE
Images from the collections etched onto the windows surrounding the Ransom Center's south atrium, 2003. *Clockwise from top left:* illustration of Oliver Twist; David Douglas Duncan's photograph of Picasso's eyes, 1957; Walker Evans's photograph "Allie Mae Burroughs," 1936; engraving of Lunardi's balloon ascent in London, ca. 1785; Edward Steichen's photograph "Gloria Swanson," 1924.

to Texas. In examining the tradition our Texas predecessors had bi-focal vision—historic and prophetic. They looked backward to the great accumulations of knowledge like the Alexandrian Library; they also looked forward to the future needs of Texas. Something of what they saw and what we owe to their long-sightedness is now my theme.

Early Texans were highly informal about such undertakings. Let us not for that reason underestimate either the mere accomplishments in Texas before 1900 or discount its social and economic influence on the development of this state. The first Texas lawmakers (lacking a Library of Congress) borrowed their books in great numbers from an Austin merchant who had invested in cotton and the classics. The historical significance of this fact has been obscured by such quaint reports as the one that this Austin merchant bought two dozen egg baskets in which to deliver books to the lawmakers. There is a steady testimony in the eighteen thirties, forties, and fifties that Texas professional men—especially lawyers, doctors, business men, and theologians—insisted that Texas must have available for immediate recourse and for future development collections of knowledge. Of course collections of knowledge have always had their detractors. Texas has produced her share of such detractors, some in official position. In every generation "Act, don't think," has been the special plea of people who are afraid of the works of the mind. Two years after the Society was founded, the *Houston Morning Star* entered such a plea:

We Want No More Men of Talent in Texas:
Heaven knows that one of the greatest obstacles to the advancement of her interests has ever been the overwhelming number of men of talent.
We want no more lawyers, physicians, or ministers for the next 20 years.

Despite such understandable preoccupation with short-range tasks of a developing economy, Texas has accomplished a good deal since the date of that complaint, and since the days when legislators borrowed their books in egg-baskets from a general store on Congress Avenue.

At the turn of the century the consul-general from Norway and Sweden, who kept that store, gave to the people of Texas the first research library in the state. Somewhat later an institute dedicated partly to the advancement of science arranged to import from Europe what, until recently, was the largest single collection of learned serials in this part of the world. By painfully slow stages a professor in a church-supported college built a research library upon the name of a single writer. Canny investment of an early endowment helped to develop a small city library on the coast into a productive center for study. Here and there other local establishments under the aegis of a college or a church or a regional museum or small archives, made independent contributions.

To name every such independent development would require the rest of the evening. In connection with these collections of knowledge, public and private, it should be remembered that many of them have been occupied with the simple problem of keeping open. The state owes a great debt to the donors, trustees, and librarians who have managed that difficult task.

Between World War I and the Depression three major research collections came together in Texas. The first was bought for Texans by a cattleman and banker from the heirs of a Chicago meat packer. It was a magnificent library, partly because the principal agent in its collection had been that famous dealer in rare oils and redoubtable bibliographer, Thomas J. Wise. Texans felt some embarrassment and some consternation when it was discovered that this same Wise had also been the most prolific book-forger of all time. A happy ending—and somehow happy endings are appropriate to this kind of story—came in the slow realization that precisely because Wise the forger had built the library, Texas possessed an almost unparalleled collection of his forgeries, which for purposes of research were quite as important as the hypothetical first editions might have been.

Harry Ransom as a young professor, ca. 1938. Unidentified photographer.

Soon another collection joined the first. It was more pedestrian in origin, getting its start with the books of an amateur scholar who made his living in the British postal service. When this man died, his library was offered for sale. There is nothing remarkable about the story up to this point. But the collection was purchased by act of the Texas Legislature—the first time, so far as I can discover, that a state's law-making body had concerned itself in this way with research. Many state legislatures since that time have followed the example set in Texas. Texas has seldom repeated it.

The third collection to become a part of the state's resources was founded by a Texas housewife upon a simple family library and was extended by her, with the help of wide-roaming agents, into an important source of knowledge. Few libraries of any kind have been more natural in their origin; few have worked more immediate good; and very few of the same size have spread their influence more widely.

Later annals of this kind of collection in Texas continued to be lively. A noteworthy experiment in Dallas has suggested the uses of photography in gathering knowledge; a Texas battle monument has become an important scholarly center. The hall which houses the secretarial office of this Society has become a vivid and useful symbol of intellectual progress. Revived interest in local archives throughout the state preceded the recent clamor about the major public collections in the capital city. A newspaper foundation has brought to Texas a great literary collection. A business man and a building association have joined their philanthropies in fortifying a new collection. A geologist and book-

man, by gift of his private library of modern writing, has led a talented company of young scholars into new fields of study. All this is venture capital placed upon the sound business proposition that Texas has an intellectual future.

Yet against these gains, we count our losses. Last year, for example, a major collection of Americana specially suited to research in Texas was offered to the state. It went to California. If numerous incidents of this kind leave us complacent, who can be placid at the news that New Haven, Connecticut, not Austin, must hereafter be the place where scholars study two out of three of the rare sources of Texas history before 1845? It is a pleasure, of course, to think of a Texas center in a great private university in the East. Certainly Texas should be studied more (and also more seriously, if one is to judge by reports of the state in public print and reflections of it in recent cinema). On the other hand, it is disturbing to note that simply because for many years we Texans have had our hands full, we have let slip such things as records of the state's growth and other instruments of learning even more important to our future development.

To questions about guaranteeing the intellectual future of Texas, there is no single answer. But from the books of the first Philosophical Society, we can take at least one leaf—that which pleads for the collection of knowledge. With a clear view behind us and with a vivid prospect ahead, why should Texas not establish here in the capital city (in connection with the state university and in affiliation with all the related libraries owned by the people of Texas) a center for the collection of knowledge, a "central" for the diffusion of information? The great urban, regional, and national centers for the collection of knowledge in London, Paris, Dublin, and Edinburgh were begun on an almost pitiable fraction of what this state could spend. A library research center would save its operating expenses in moneys now spent by Texas institutions, industries, and individuals who must go where knowledge has been massively collected or do without. Future Texans will be too ambitious to do without. What is more important than comparisons of expense with savings is the fact that by means of such a research center Texas could attract more of the talent, skill, knowledge, and wisdom which it needs now and will need in the future. Most important of all, young Texans who now are persuaded to leave the state for collections elsewhere might be persuaded by such a research center to stay; and some who have left might be persuaded to come back. We can now afford expenditure of Texas moneys. We cannot afford the waste or the loss of Texas minds.

Texas has accomplished much. It still has much more to accomplish. If we oldtimers who believe profoundly that the state has not reached the top of its intellectual bent are accused by our contemporaries of

making disloyal sounds, we must appeal to the proclamation made in 1837 by certain newcomers, including Mirabeau Lamar, Ashbel Smith, and Sam Houston: "Texas calls on her intelligent and patriotic citizens to furnish to the rising generation the means of instruction within our own borders."

This was no mere summons to meet the immediate, practical needs of a new republic. These men were capable of looking into the future, and what they saw is still our main obligation. Somehow by making Texas what they prophesied it might be we must persuade more and more first-rate younger scholars to think about Texas, to count on Texas, to stay here—or having left, to come back.

And now my argument has gone full circle. I return to the ancient need of every knowing society: the collection of knowledgeable people. By the development in this capital of a center comparable to the great national and regional libraries—each of which began with more modest foundations than Texas has already laid—we would get to the state more than past glories, more than tremendous uses of the permanent records of man's attainments. We would get here, develop here, and keep here more creative minds, the first essential in the collection and diffusion of knowledge.

Special thanks to all Ransom Center staff, past and present, who contributed their memories, support, time, and talents to this project, especially Tom Staley, Richard Oram, Cathy Henderson, John Thomas, Mary Beth Bigger, Sally Leach, Jean Townsend, Kurt Heinzelman, Pete Smith, and Eric Beggs.

Thanks to René Payne for obtaining copyright permissions, Jim Dirkes for assisting with image selection, staff of the Center for American History at The University of Texas, Marsha Miller of the UT Office of Public Affairs, Walter G. Riedel III of the Nelda C. and H. J. Lutcher Stark Foundation, Jim Burr and his associates at the University of Texas Press for their guidance and good work, and Brian Cassidy for his unending patience and support.

All photographs, unless otherwise credited, are by Eric Beggs or Pete Smith. All photographs were prepared for publication by Pete Smith.

Publication of this book was made possible by the generous support of Van and Jeanne Hoisington and Jack and Janet Roberts.

ACKNOWLEDGMENTS

COLLECTING THE IMAGINATION

BEGINNINGS

THE RARE BOOKS
COLLECTION,
1897–1955

John B. Thomas, III

THE FIRST COLLECTIONS

The history of the Harry Ransom Humanities Research Center at the University of Texas is not simply the story of a small library collection grown large. Part of what makes it different—what gives it flavor and notoriety—is that it happened in Texas, amid the rich brew of money, power, politics, oil, ambition, and unbridled pride so characteristic of the state. These factors have colored its history—at times propelling it into myth, controversy, and exaggeration—and influenced every phase of the evolution of a once modest library that has grown in both size and stature.

The people of Texas set the tone for the University when they approved the state constitution of 1876. Typical of Texas pride, it contained a clause that mandated the creation of a state university "of the first class."[1] This clause has been invoked for more than a century in appeals to the legislature for more money, more buildings, more faculty, more students, and, of course, more books. The legislative response has often been tepid, and it was noticeably so in the beginning. Perhaps to compensate for meager appropriations, the legislature granted the University more than two million acres of land in West Texas. The land was poor, dry, and remote, and for years the only revenue it generated was from the sale of grazing rights, which brought little income. Everything changed, however, on May 28, 1923, when oil was discovered under this land. The oil provided a steady and robust infusion of funds that would enable the University and its library collections to grow substantially. For years, however, the University had to get by with more modest resources.

The campus library was in place almost from the start. It was small and remained small for years, its growth heavily dependent on state appropriations. In 1897, the library's first major benefactor, Swante Palm,

Power, money, and influence in Texas libraries. Harry Ransom (left) with Pat Nixon, John Connally, Ben Barnes, Frank C. Erwin Jr., Lyndon B. Johnson, Lady Bird Johnson, and Spiro Agnew at the dedication of the Lyndon Baines Johnson presidential library, 1971. Unidentified photographer.

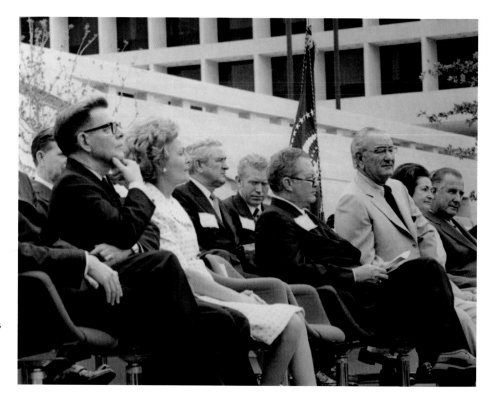

Typical West Texas scene. Not shown is the oil and natural gas underground, the source of the University's ancillary funding. Photograph by W. D. Smithers, not dated.

a Swedish bibliophile and merchant who had immigrated to Austin, donated his ten-thousand-volume collection to the University library, nearly doubling its size. Swante Palm offered his curatorial services as well, and he became the first of several owners or curators who accompanied their collections to the University.

Swante Palm's collection was rich with materials related to Swedish literature and history. Although the collection was fairly specialized, it was amassed into the general library holdings, for there was only one campus library in the early decades of the University. Years later, as the University matured and added departments, schools, colleges, and graduate programs, the campus library evolved as well and became differentiated into a main library and its adjunct departmental, special materials, and rare book collections.

Even as the University's library grew, many members of the faculty, trained in a nineteenth-century German tradition of scholarship, felt the want of primary research materials on campus—the original texts, rare editions, and manuscripts on which they could base their research. Seeking to obtain such indispensable books and manuscripts, scholars from the English Department allied themselves with the library. Several faculty members from the department, including the Alexander Pope scholar Reginald Harvey Griffith, were involved in serious bibliographic and literary research, and primary materials in their areas of scholarship were highly desired. In 1917, Griffith found a private library for sale that

LITTLEFIELD VERSUS BRACKENRIDGE

An unusual impetus to philanthropy in the early decades of the University was the rivalry between George Washington Littlefield and George Washington Brackenridge. Both were University regents, both were bankers, and both were wealthy, but otherwise they were opposites. Littlefield had been a Confederate officer; Brackenridge was a Union sympathizer. Littlefield was a family man and rancher; Brackenridge never married and was from a strong commercial background.

Both had long terms as University regents, and between 1917 and 1919 they served at the same time. It was during this period that both were instrumental in obtaining and publicizing the Wrenn Library, the foundational collection of what would eventually become the Ransom Center.

They gave other gifts to the University and its library as well. Littlefield established a fund for the purchase of books on Southern history, and it is still used for this purpose today. He also planned and paid for the University's South Mall, which serves as a war memorial with particular attention to Southerners, whose statues form a perimeter. A dormitory for women on campus bears his name and was given to honor his wife, Alice. His decisive stamp on the University is his home, which now houses a portion of the University Development Office and still stands as a magnificent edifice.

Brackenridge does not have as strong a presence on campus, although a men's dormitory bears his name, and he founded several trusts to provide tuition for female students. A particularly important gift of his, however, is located a few miles away on the banks of the Colorado River: the Brackenridge Tract. He gave this land to the University, hoping that the school would move its campus to the tract. The University accepted the gift, but declined the relocation. On the tract now resides married student housing and a research center for the natural sciences. A great deal of the land is leased out, heftily augmenting the University's annual income.

Many Texans will be more familiar with the legacy of each away from the University: the Littlefield Building in downtown Austin (the first high-rise office building in the city), and Brackenridge Park in San Antonio, next to which stands Brackenridge's home, every bit as impressive as Littlefield's in Austin.

Portrait of University benefactor George W. Littlefield, flanked by John B. Thomas, III, Curator of the Pforzheimer collection, and Thomas F. Staley, Director of the Harry Ransom Center, 2005

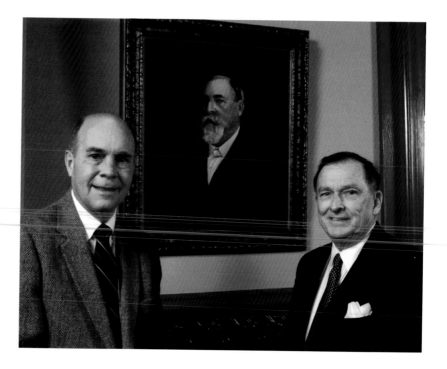

would immeasurably strengthen the University's holdings, and it was purchased through the good offices and ample wallet of benefactor and regent George W. Littlefield, who then donated the collection to the University.

The library had been formed by Chicago financier John Henry Wrenn with the help of English bibliographers and booksellers, and it was sold to Major Littlefield by Wrenn's son Harold. English literature of the seventeenth and eighteenth centuries in first or significant editions formed the bulk of the collection, but it also had surprises, such as a complete run of publications from the notable Kelmscott Press and first editions of many nineteenth-century works of prose and poetry. There were other surprises as well—fakes, corrupted books, and stolen items—but they would not be discovered for years.

The Wrenn Library was the founding collection of what would eventually become the Harry Ransom Humanities Research Center, and it was the first special collection at the University to have its own housing and staff separate from the main library. The collection was installed in the stately old library building (now called Battle Hall), where it became the basis of the University's Rare Books Collection.

The early staff of the Rare Books Collection was small, perhaps consisting of only one or two people. By 1920, Fannie Ratchford was working in the collection as a library assistant, and she soon assumed charge of the entire operation. Ratchford and the collection's staff were responsible for answering questions, locating and retrieving books for faculty and students, and eventually preparing exhibitions and modest displays of collection materials. The acquisition of texts, whether additional rare books or reference books to be used in conjunction with the collection, was made through the main library, and thorough cataloging of materials was not undertaken at this time.

The 1920s were years of great expansion for all campus special collections, and by then there were several, including small holdings related to law and Texas history. The University's Latin American Collection (now called the Nettie Lee Benson Latin American Collection) got its start in 1920, appropriately, on a street in Mexico City. University regent H. J. Lutcher Stark, one of the school's great benefactors, was in Mexico City to attend the inauguration of Mexican president Álvaro Obregón. After the festivities, he and Professor Charles Wilson Hackett spotted in a bookstore window a first edition of Bernal Díaz del Castillo's *Historia verdadera de la conquista de la Nueva España* (*True History of the Conquest of New Spain*), an account of the Spanish conquest of Mexico. Hackett remarked that the book belonged in the University's library. Stark agreed and purchased it for Texas. Six months later the University bought—through the same book dealer—the impressive library of Genaro García, a Mexican senator, historian, and collector.

The García collection is to the University's Latin American Collection what the Wrenn Library is to the Ransom Center—its founding collection.

During the 1920s, the Rare Books Collection built on its strengths and continued to address the research needs of the English Department. In 1921, Reginald Griffith located another important collection of early English literature, and Harold Wrenn, who had not tired of promoting collections, was instrumental in arranging for its purchase. The collection, formed by English scholar George A. Aitken, was composed primarily of literature of the early eighteenth century, with a wealth of material on Alexander Pope and an unparalleled collection of early English newspapers and magazines. It was undoubtedly a great resource for Professor Griffith and his colleagues and remains a favorite with researchers today. The collection had depth, and it complemented the Wrenn Library.

The Stark Library was the third and last major acquisition for the Rare Books Collection until Harry Ransom assumed its directorship in the 1950s. A treasure collection, full of rare books on all subjects and from a variety of periods, it was pledged as a gift to the University by the Stark family in 1925, but the great bulk of materials did not arrive until 1936, when suitable quarters were available. The collection was diverse, containing all four of the first folio editions of Shakespeare as well as the usual sets of authors' collected works. Especially noteworthy were the first editions and manuscripts by Byron, Keats, Shelley, and other writers of the Romantic period. The library also included a collection of letters from Thomas Jefferson to American painter Charles Willson Peale, augmenting the University's holdings in American history. Considerable taste and technique went into the making of this collection. Although some of the represented authors have retreated from the scholar's purview, other riches, notably the manuscripts of English Romantic writers, continue to grow in appeal.

THE SOCIAL SETTING

The Stark Library was one of a series of gifts made to the University by the Stark family, and it was created by lovers of books, not academics or scholars. The University's Rare Books Collection, like most academic and institutional rare books libraries, owes a great debt to astute collectors like the Stark family. Rather than purchase individual books or manuscripts, most institutional libraries grow by acquiring large private collections that add to their strengths and expand their scope. Such collections not only augment their holdings but also infuse institutional libraries with the taste, connoisseurship, knowledge, and personality

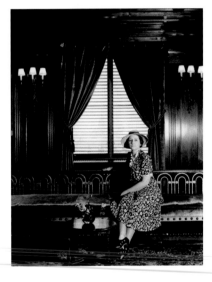

Nita Hill Stark in the library bequeathed to the University by her parents-in-law, Miriam J. and William H. Stark, ca. 1938. Nita Stark had several ties to the University: her husband was regent and benefactor Lutcher Stark, and her father was the unofficial medical liaison to the University's football team. Unidentified photographer, Center for American History, the University of Texas.

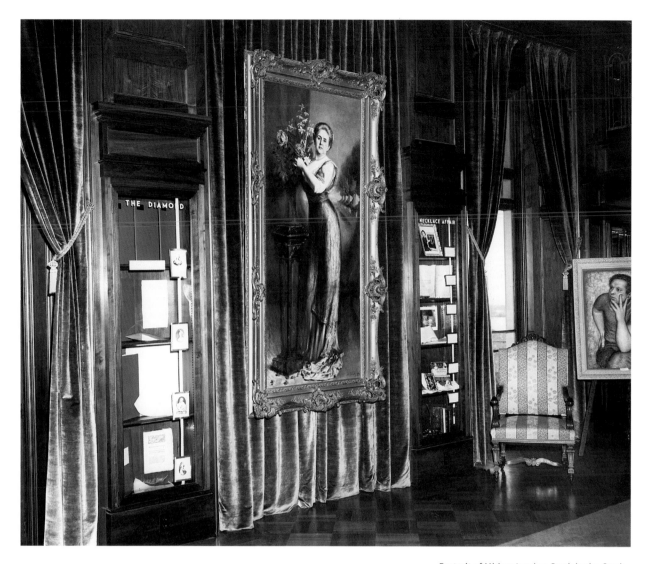

Portrait of Miriam Lutcher Stark in the Stark Library. The portrait is flanked by a display of books and manuscripts from the Rare Books Collection. Also visible is Alfred Janes's portrait of Dylan Thomas. Unidentified photographer, not dated.

of the private collector. Institutions often develop strong relationships with these collectors and their donors. The Stark family was no exception, and they became quite close to the University and especially to Fannie Ratchford. The social aspect of the activities and endeavors of the Rare Books Collection was important to Miss Ratchford, and she did well in the part of her job that called for pleasing the Starks.

The Stark family made its fortune through their land and timber company, Lutcher and Moore, which was founded by Henry Lutcher and grew to include large holdings in coastal Texas and Louisiana. William Henry Stark, a promising employee, married Lutcher's daughter, Miriam, and the couple settled in the company town of Orange, Texas, just across the Sabine River from Louisiana. Their home became a center of culture and philanthropy, following strong traditions already found in the elder generation of the Lutcher family.

With position came a wider sense of responsibility. Besides their local philanthropy (still extensively carried on in Orange and surround-

ing areas by the Stark Foundation), the family looked more broadly to the state, and their main enterprises centered on its flagship university. Eventually, both William Henry Stark and his son H. J. Lutcher Stark (always known as Lutcher) served on the Board of Regents. Lutcher became a good friend to the University libraries, contributing to both the Rare Books Collection and the Latin American Collection and funding significant acquisitions into the 1950s. In Texas, it is especially notable that he was also a prominent supporter of the University football team.

When the Starks offered their large collection of books, furniture, and decorative items to the University's Rare Books Collection, the rooms in the old library building were quite full with the Wrenn, Aitken, García, and other collections. The family decided not to pack and ship the majority of their books until suitable quarters could be established. As the family began to concern itself with housing the collection at the University, they participated in the planning of a new main building on campus, which would dedicate substantial space to the University's library and the Rare Books Collection. As both a regent and a private benefactor, Lutcher Stark contributed generously to the funding of the new building. For this reason, the new home of the Rare Books Collection, fitted with Stark furniture, art, draperies, and china, reflected the taste of his family.

SCHOLARSHIP AND SCANDAL

Beginning a long tradition of publishing works related to its holdings, the Rare Books Collection issued its first publication, a five-volume catalog of the Wrenn Library, in 1920. The catalog had been prepared prior to the sale of the collection and merely needed funding for its publication. The necessary funds were generously provided by Harold Wrenn and longtime University benefactor and regent George W. Brackenridge. Unbeknownst to Ratchford and the University, however, the catalog was full of misattributions, poor descriptions, and dishonest bibliographic collations. Indeed, it has become a collector's piece for its mistakes. The blame for the catalog's faults can be assigned to its compiler and editor, the infamous Thomas J. Wise, who was at the time a respected British bibliographer but was later discovered to be a thief, fabricator, and bibliographic charlatan. The dishonesty that pervaded this catalog and Wise's other publications aroused suspicions that led to startling revelations a decade later.

The publication of the Wrenn catalog was followed by a far more accomplished endeavor for the Rare Books Collection: the compilation and publication of Reginald Griffith's monumental, and still unsur-

passed, bibliography of Alexander Pope, published by the University
in 1922. It drew not only on Griffith's personal collection (given to the
University in 1956, shortly before his death) but also on the Popean
riches of the Wrenn and Aitken libraries.

Fannie Ratchford was committed to the promotion of research in
the Rare Books Collection, and she was equally active as a facilitator of
scholarly inquiry and as an author. She used the collection extensively
for her own research and published widely throughout her tenure. In
the 1920s she published scholarly articles on Lord Byron, Alexander
Pope, Algernon Charles Swinburne, and Samuel Taylor Coleridge, and
the first of several of her investigations of the childhood writings of
the Brontë family. During later decades, she wrote substantial books
on the Brontës and on aspects of American frontier history, one of
her long-standing research interests.[2] Her scholarship was recognized
by the Guggenheim Foundation, which awarded her three fellowships
during the course of her career.

Ratchford was compelled to write several other books in response
to an event that scandalized the library world in 1934: the discovery
that Thomas J. Wise, bibliographer and agent for many prominent rare
book collectors, including George A. Aitken and John Henry Wrenn,
was a forger and a thief. The revelation was made by bibliographers
John Carter and Graham Pollard in their 1934 book, *An Enquiry into
the Nature of Certain Nineteenth Century Pamphlets,* and the evidence
was conclusive. Wise had created, and then promoted and sold, first
editions that were no such things. To take one example of his mis-

The Wrenn Library, ca. 1938. Photograph by University Studio, Center for American History, the University of Texas.

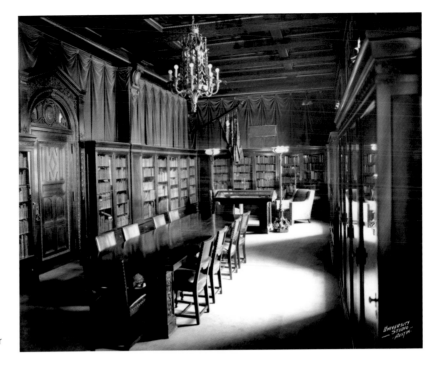

The Stark Library as installed at the University, ca. 1937. It looks much the same today. Unidentified photographer, Center for American History, the University of Texas.

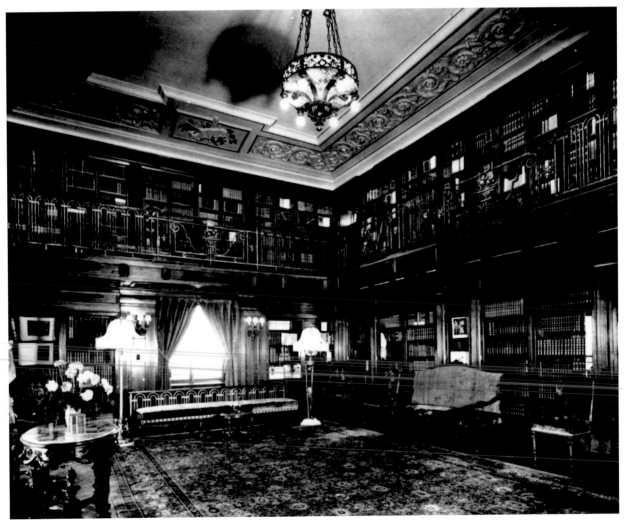

COLLECTING THE IMAGINATION

chief—and there are a hundred more—he "discovered" and then sold to selected wealthy clients the previously unknown first edition of Elizabeth Barrett Browning's *Sonnets from the Portuguese*. He even concocted a story of how the book came to be published and how a few stray copies had come into his hands. There had been suspicions about this book long before Carter and Pollard published their *Enquiry* for several reasons: no surviving copy was inscribed by the author or any of her contemporaries, Wise's story of the circumstances of its publication had no antecedent in any correspondence of the Brownings and their circle, and the momentous event of the book's publication was not mentioned in diary entries by the Brownings or anywhere else. The *Enquiry* confirmed the validity of the suspicions and proved without a doubt, based largely on the analysis of paper and type, that the *Sonnets* and many other "first editions" promoted by Wise had been set in type and printed at a much later date. Wise did not respond to his critics, but the arguments against him were quite convincing. His reputation as a bibliographer and arbiter of authorship and taste was ruined, and his many bibliographies of major authors are no longer consulted.

Ratchford was convinced by Carter and Pollard's meticulously researched presentation, and in the 1940s she published several articles and two substantial books that further clarified the crime, based largely on research done on books and manuscripts in the Rare Books Collection.[3] Further chicanery was revealed in 1959 when English bibliographer David Foxon and University of Texas Professor William B. Todd showed that Wise corrupted other books by stealing leaves from one copy and then piecing them into another copy to make more saleable books. The Aitken and Wrenn collections proved to have more than a hundred of these corrupted copies, which suffered a much diminished value for research. Many public and private libraries on both sides of the Atlantic were similarly infected with these tarted-up books. Attempts to reunite stolen leaves with the books they were taken from were eventually abandoned because the undertaking proved impossibly complex.

A QUIET OPERATION

New facilities for the Rare Books Collection opened in 1937, following the completion of the University's new Main Building. Three large and imposing rooms were devoted to the Wrenn, Aitken, and Stark libraries respectively. A fourth room served as a reception and exhibition area. The Wrenn Room, modeled after the library of Sir Walter Scott, included carved walnut bookcases and vaulted ceilings with beams decorated with printers' marks and university seals. Leaded-glass windows

OPPOSITE PAGE, TOP
Exhibition and reception room of the Rare Books Collection. The entrance to the Stark Library is visible in the background. Unidentified photographer, not dated.

OPPOSITE PAGE, BOTTOM
Students and scholars at work in the Rare Books Collection. Unidentified photographer, not dated.

depicting the coats of arms of English colleges and allegorized female figures completed the picture. The Stark Library was decorated and furnished courtesy of the Stark family with velvet hangings, rugs, gold-washed light fixtures, and furniture from the Stark home in Orange. The family also oversaw and paid for such mundane but essential details as the air conditioning and plumbing for the new facilities. There were two terrace gardens—one off the Aitken Library and the other off the Stark Library—that afforded fine views and tranquil retreat for researchers and staff. Following the gift of a tea set from the Stark family, Miss Ratchford began to serve tea and coffee to researchers—often in the terrace gardens—paying for the supplies out of her own salary. It was an elegant space for a small and quiet operation.

Exhibitions were held in the new facilities, and many were accompanied by published catalogs. In 1934, cataloging of the collections began, initially as a Works Progress Administration project; records for the Wrenn and Aitken libraries were completed, and the first records of the Stark books and manuscripts were prepared. Research continued among the collections, conducted by old-school stalwarts such as Ratchford and Griffith, and by Edgar Allan Poe scholar Killis Campbell and American literature specialist Leonidas W. Payne (both of the University's English Department). There were also newer patrons of the collections, including English professors Clarence Cline and William

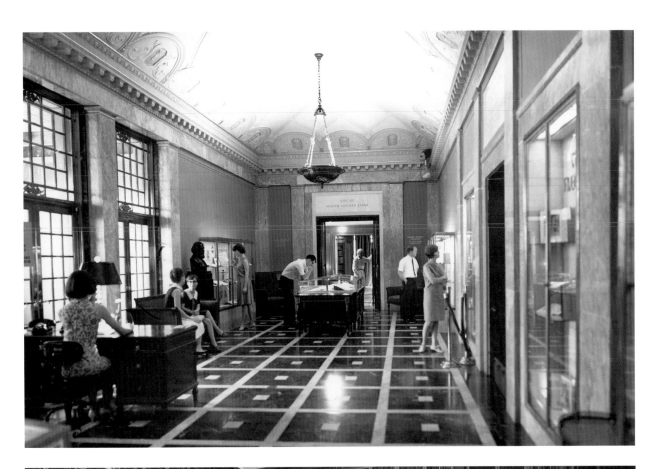

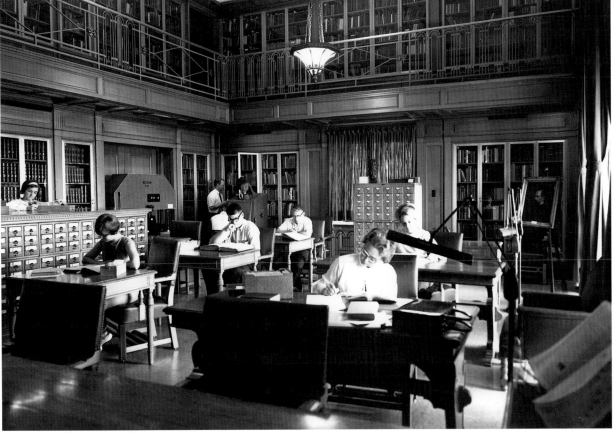

On April 19, 1943, the Texas House of Representatives voted 99 to 17 to order an investigation into the 1939 purchase of nine rare books by the University of Texas. The resolution, submitted by C. S. McLellan of Eagle Lake, charged that money appropriated by the legislature for cataloging and maintaining the Stark Library was used not for this purpose but to fund the book purchases. An investigative committee was asked to determine how the money was spent and whether any portion of it went toward "obscene" literature or books on atheism.

The nine books under investigation were purchased at auction from the renowned collection of John Alden Spoor, a friendly rival of collector John Henry Wrenn, whose library formed the foundation of the University's Rare Books Collection. Two books were under particular scrutiny: a fifteen-page volume of Percy Bysshe Shelley's *The Necessity of Atheism,* one of two known perfect copies (purchased for $9,300), and an edition of Lord Byron's *Fugitive Pieces,* notated in Byron's hand and one of only three perfect copies (purchased for $3,100). McLellan was especially incensed by what he deemed to be an exorbitant expenditure for a "lewd" and "suppressed edition by Lord Byron which is not fit to be read by any person within or without the

university."[1] Furthermore, McLellan objected to the University's display of the Shelley book on atheism, for the display offered no explanation as to whether the University approved of the book—or its title.

McLellan appeared to object to the very philosophy of purchasing rare editions for research and scholarship. He said, "From a collector's standpoint, spending $9,000 for one book may be justifiable. But I think the same mate-

rial is available in a 10-cent edition."[2] He argued that taxpayers' money ought not to be spent on rare books for the University, though he did not object to the donation of rare editions from "public-spirited" individuals.

In spite of McLellan's objections, the Stark Library survived the investigation. The books in question remain in the collection, available for the edification of researchers, students, and scholars to this day.

Lord Byron's *Fugitive Pieces,* one of the books under investigation by the Texas legislature in 1943

B. Todd. In spite of low state appropriations for acquisitions, materials continued to be added to the collections, though at a slower pace than in previous decades. The most notable acquisition of this later period was a gift by Everett Lee DeGolyer of 1,300 first editions of modern authors. It augmented the newer material in the Aitken collection and added important works by Southwestern writers.

The activities of the Rare Books Collection, however, had become less bold and adventuresome, more etiolated, no longer fresh. Perhaps this languid tone was set by the University as a whole; other rare book collections on campus, including the Latin American Collection and the Texas Collection, were quieter during this period as well. The attitude of the time could be discerned from the University's treatment of another philanthropic gesture of the Stark family. Although the University had acquired the Stark books and manuscripts, the Starks also had a significant art collection that remained in Orange. Following the deaths of Miriam and William Henry Stark in 1936, their son Lutcher offered the collection to the University with a proviso that a museum or gallery be provided for it. The University accepted the offer but did nothing to designate a gallery to house and display the collection. In the 1950s, Lutcher Stark gave up and built his own art museum in Orange to house his personal collection. The art that his parents accumulated, homeless for decades, has finally been auctioned off.

A prime reason for the slowing tempo was—as is often the case—money. The state had never appropriated much for the Rare Books Collection, and it did not increase funding in this period. The University relied heavily on gifts and benefactors but was not always adept at fostering donor relations or enterprising in cultivating new patrons. The direction the Rare Books Collection took in this period was also set by Fannie Ratchford and reflected what was expected of her, what her capabilities were, and what opportunities arose. Ratchford was not trained as a librarian, though her want of formal training did not keep her from doing a prodigious amount of library work. Her interests were more scholarly, and she published many insightful books and articles and encouraged scholars in their investigations of the collections. She supervised the staff and users of the collections with strong guidance as to conduct and decorum, which suited the tastes of many of the University's administrators and donors. She was very good, and very ingratiating, in the cultivation of the Stark family, the Rare Books Collection's most important benefactors. She even tried to raise money for acquisitions and the running of the library by attempting to form a friends of the library group in the 1940s, but this venture was ultimately unsuccessful.

But Ratchford had her limitations. She did not try to expand the collection into new areas; rather, she built on the collection's strengths

Fannie Ratchford in the Rare Books Collection. Photograph by Luckett and Glover, not dated.

in eighteenth- and nineteenth-century literature with conservative and traditional acquisitions. Although she cannot be faulted for championing the best of the old, she seemed uninterested in modern literature and disliked modernism and experimentation (she was neither modern nor experimental in her social interactions). Ratchford showed no particular interest in new types of materials such as author archives, and she had little use for anything that smacked of popular culture. But she recognized enterprise when she saw it, writing after a 1954 visit by Lawrence Clark Powell, Director of the library and rare book collections at UCLA, "Isn't it wonderful to know how to build a great research library and have the authority to do it?"[4]

ECLIPSE

Miss Ratchford was largely a caretaker in the last decade of her forty-year career, and she was decidedly old-fashioned. When Harry Ransom, a young professor of English, entered the scene and tried to advance the fortunes of the Rare Books Collection in the 1940s, she may have welcomed the interest. When she perceived that he had grand plans and sought to transform her domain, however, she was sometimes hostile. In the academic year of 1957–1958, he succeeded her as director of the Rare Books Collection, soon to be renamed the Humanities Research Center, and she left for a well-earned sabbatical in England (to pursue research on Foxon's discoveries of new Wisean mischief; for the investigation she obtained her third Guggenheim award). She did not let go of her long involvement lightly, and in 1958 she wrote several letters to Lutcher Stark in Orange, continuing their long correspondence. In one, she said that she was gratified that, with Ransom, the Rare Books Collection had finally achieved the academic stature that she had longed for. In another, however, she expressed anger that a replica Italian statue that once resided in the exhibition room of the Rare Books Collection had been replaced, in her words, by "hideous bronze busts of Shaw, Conrad," and other modern writers.[5]

NOTES TO TEXT

1. Texas Const. of 1876, art. VII, sec. 10.

2. Ratchford, *Legends of Angria,* with William Clyde DeVane; Emily Brontë, *Two Poems; Love's Rebuke; Remembrance,* ed. Fannie Ratchford; and Ratchford, *The Brontës' Web of Childhood.*

3. See Ratchford, *Letters of Thomas J. Wise to John Henry Wrenn* and *Between the Lines.*

4. Ratchford to Mrs. M. T. Blackford, May 29, 1954, Ransom Center collection.

5. Ratchford to Mr. and Mrs. Stark, February 15, 1959, Stark Foundation archives.

NOTES TO SIDEBARS

1. Lorraine Barnes, "House Gives Rare Books Hard Look," *Austin American-Statesman,* April 19, 1943.

2. "No. 1 Marine Hero to Address Statewide Victory Day Program," *Dallas Morning News,* April 20, 1943.

THE BIRTH OF AN INSTITUTION

PART 2

THE HUMANITIES
RESEARCH CENTER,
1956–1971

Cathy Henderson

RANSOMIZED

Harry Huntt Ransom, the man who would change the course of the Rare Books Collection and eventually serve as its namesake, joined the University of Texas in 1934 as an instructor of English. He immediately acquainted himself with the University library and the Rare Books Collection, where he would devote much of his time, energy, and attention for more than forty years.

A native Texan, Ransom was born in Galveston in 1908 and raised in Houston and Sewanee, Tennessee, where he remained to attend the University of the South. After graduating in 1928, he attended Yale University and earned both a master's degree and a doctorate in English. At Texas, Ransom advanced to assistant professor in 1938 before taking a sabbatical to serve in Army Air Force intelligence during World War II. He returned to the University as an associate professor in 1946 and became full professor of English a year later. In 1947, Ransom assumed his first administrative position as assistant dean of the graduate school, and in this capacity, he began to work more actively with Fannie Ratchford to define the academic role of the Rare Books Collection and to grow its acquisitions budget.

In 1947, Ratchford agreed to act as secretary to a nascent, though ultimately unsuccessful, friends of the library group, organized to encourage outside funding for future acquisitions. An invitational letter that went out to prospective members cautioned against complacency and appealed to Texas pride:

[G]ood as Texas libraries are, they are still far from the Texas ideal, "as good as the best." They are far from as good as they should be in terms of the wealth and patriotic pride of Texas, and far from as good as they could be, were funds available to take advantage of our opportunities for

purchase . . . [I]t is not to public tax money that our research libraries can look for continued growth. Future expansion, like present greatness, must come through the gifts of devoted men and women who choose this means of serving their state.[1]

The need for such a friends group was clear. Between 1944 and 1949, the University added an average of only seventy-five titles a year to its Rare Books Collection. A gift by Everett Lee DeGolyer in 1946 of 1,300 first editions of modern authors and the gift-purchase of the William M. Roth collection of William Butler Yeats editions in 1950 were notable exceptions that anticipated the Center's future collecting focus. To Ransom and others, it was clear that the modest pace of acquisitions in this period was preventing Texas from building a truly great collection. They sought to supplement the meager acquisitions budget and add significantly to the holdings of the Rare Books Collection.

In 1948, the Committee on the Rare Books Collection, on which Ransom served, recommended greatly increasing acquisitions of rare books and manuscripts and a commensurate rise in the annual acquisitions budget from $750 to $25,000. A 1950 report published by the University in its journal the *Library Chronicle* noted the fruits of this request: "Thanks to a special Regents' appropriation, Rare Book Collections has recently enjoyed an unusually large flow of acquisitions." Among the newly acquired materials were "old English newspapers, dictionaries, herbals, seventeenth and eighteenth century books. . . , bibliographies, and autograph letters and other manuscript material to swell source holdings in the Romantic and Victorian fields."[2] Nothing in this list suggested that Texas was soon to break with its traditional collecting practices and greatly expand the scope of its interests.

Harry Ransom with University of Texas students Diane Garrett (left) and Martha Brindley (right), looking at a selection of rare books, 1964. Unidentified photographer.

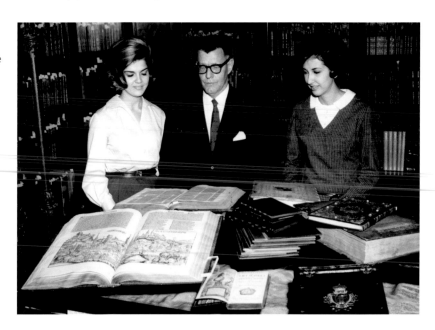

COLLECTING THE IMAGINATION

Ransom was less successful at this time in helping to secure academic status for the Rare Books Collection and its director, a goal he shared with Ratchford. The Board of Regents and the Committee on the Rare Books Collection declined to interfere in what they viewed to be an administrative matter, and thus Ransom wrote privately to University President T. S. Painter in support of a reorganization of the Rare Books Collection. In his letter, he cited three convictions that presage some of his later actions as dean, vice-president and provost, president, and chancellor: first, that "the rare books collection in any university must be a research and teaching function if it is to realize its full potentialities"; second, that rare book collections aided recruitment of talented faculty and served as a "central laboratory" for research in the humanities; and third, that the University could only guarantee "a future of distinguished service" for the Rare Books Collection by upgrading its director to professorial status.[3] It would be years, however, before the collection would receive the academic distinction Ratchford and Ransom desired.

Everett DeGolyer, who donated to the Center thirteen hundred first editions of modern authors in 1946. Photograph by Chase Studios, New York, not dated.

In 1953 Logan Wilson was selected president of the University of Texas. During his tenure, he made several changes that enhanced and supported the Rare Books Collection. Perhaps his most notable accomplishment was the passage of a state constitutional amendment to expand the uses for the Available University Fund (the interest and income generated from the Permanent University Fund, an endowment supported by land granted to the University by the state legislature). The amendment enabled the University to use this rich fund for a variety of purposes, including the purchase of library materials. Wilson also contributed to the creation of the Texas Commission on Higher Education, which came to support and encourage a library enhancement program. In 1954, Wilson appointed Harry Ransom to be dean of the College of Arts and Sciences, where Ransom was in a position to provide greater administrative support for the Rare Books Collection. These changes provided the environment Ransom needed to accelerate dramatically the library development in Texas.

As dean, Ransom worked directly with booksellers to identify suitable materials for the collection, but ongoing financial constraints continued to frustrate his efforts. In spite of recent budgetary increases, the Rare Books Collection could not afford many of the collections it was being offered. The University was unable to purchase either the library of Edward Alexander Parsons in 1954 or a group of D. H. Lawrence manuscripts in 1955 that had been loaned by Lawrence's widow to the University for an exhibition. Missed opportunities continued in the following years. In 1956, Ransom negotiated, unsuccessfully, for the purchase of the Carl Pforzheimer Library of Early English Literature (its Gutenberg Bible was eventually purchased by the University

in 1978, and the remaining books in the library were acquired in 1986). In 1957, however, the sale of Thomas Streeter's Texana collection to Yale University finally handed Ransom the widespread negative publicity he needed to argue effectively for greatly increased funding.

Outcry arose in Texas at the loss of the Streeter collection, perhaps because the association between Streeter and the state had been quite close. Streeter had loaned rare items for exhibitions at the 1936 Texas centennial celebration in Dallas and at the opening of the San Jacinto Monument and Museum in 1939. In 1944 Streeter gave to the University the Beauregard Bryan papers, the last-known large collection of documents related to the early history of the pioneering Moses Austin family. When Streeter made it clear that he had sold his collection to Yale because Texas libraries had not expressed interest, Ransom knew that he had the state's attention. Just weeks after the Streeter sale, he wrote to Jack Maguire, Executive Secretary of the University's Ex-Students' Association:

We are in no wise concerned simply with collecting "Texas materials" although in that field we have been desperate losers for years. A more important point . . . is that The University of Texas Library has slipped alarmingly in the past two decades. We were once one of the really distinguished university libraries; it is impossible to predict any such distinction for the immediate future unless we do something immediate and desperate about getting back into shape.[4]

Mindful of the general focus of alumni interest, Ransom, mixing his sports metaphors, concluded:

I know that more books are not likely to excite alumni as much as football. Ironically, however, one of the great collections which we are now being offered and apparently can't afford contains a magnificent collection of books on sports and illustrations of athletics from ancient archery to recent T-formations. So even the 50-yard-line zealot would have his inning in this particular business.

In a subsequent memorandum to President Logan Wilson, Ransom listed half a dozen available book and manuscript collections and their approximate price tags, totaling nearly a million dollars. In closing, he restated his concern that "since 1917—when Texas began to lead all state universities in research collection—we have steadily declined."[5] Acknowledging that the University Development Board was indeed working to raise funds for rare books and manuscripts, Ransom wrote: "To this point I would add only the simple observation that library-philanthropy is not highly developed in Texas." His unstated point was

clear: he believed that the University should reapportion the needed funds from its own resources.

On December 8, 1956, in a speech that would be invoked for decades to come, Ransom revealed to the Philosophical Society of Texas his vision for a broadened Texas library. In his speech, he proposed that "there be established somewhere in Texas—let's say in the capital city—a center of our cultural compass—a research center to be the Bibliothèque Nationale of the only state that started out as an independent nation."[6] Appealing to Texas pride and stressing the importance of a strong research center for the state, he claimed:

By the development in this capital of a center comparable to the great national and regional libraries—each of which began with more modest foundations than Texas has already laid—we would get to the state more than past glories, more than tremendous uses of the permanent records of man's attainments. We would get here, develop here, and keep here more creative minds, the first essential in the collection and diffusion of knowledge.

In his speech, Ransom identified two competing forces in Texas history: an ambition for future greatness that was impeded by a tendency toward anti-intellectualism. One of the principal motivations for his library development effort was to bring the state and its flagship university to intellectual maturity.

Ransom's speech marked a change in the course of the University's Rare Books Collection. In the months following, he developed a four-part plan to strengthen Texas's library collections. First, he believed that an attempt to build a great library one book at a time was pointless; in order to excel, the University would have to buy entire collections. Second, because Texas could not reasonably challenge the large eastern libraries in the traditional collecting areas of early printed books, it would plunge into the collecting of modern English and American literature, territory in which few institutions had set foot and prices were relatively low. Third, works by both major and minor literary figures would be collected. Finally, Ransom intended to acquire literary manuscripts as much as, or more than, rare books. Ransom presented this plan to the Board of Regents and then began systematically to put it into action. This new vision of a Texas library, with Ransom's philosophy driving it, transformed the small, quiet Rare Books Collection into what would eventually become a world-class research center. This transformation, in 1957, marked a new beginning for the institution.

One of Ransom's most strongly held convictions was the importance of documenting the entire creative process, from the author's earliest notes through the progression of manuscripts, drafts, and proofs to the first and subsequent editions of the printed text. Correspondence, royalty state-

WHY TEXAS?

Why did Alfred and Blanche Knopf donate their personal library and their publishing firm's archive to the University of Texas at Austin? Their business was based in New York City. Alfred was a graduate of Columbia University, and some of the firm's records had already been given to the New York Public Library when Knopf was first approached by Ransom. Why did they choose Texas?

Although the immediate answer does not emerge until the late 1950s, one can trace the Knopfs' association with Texas back to 1941, when, on a trip through Dallas, Austin, San Antonio, and El Paso, they met the Stanley Marcuses, J. Frank Dobie, John Henry Faulk, Walter Prescott Webb, Maury Maverick, and other prominent Texans with whom they maintained personal friendships and business contacts.

Ransom and Alfred Knopf were introduced to one another over lunch at the St. Regis Hotel in New York City on June 22, 1959. Ransom described the program he was building at the University and expressed interest in making Knopf's personal library a part of this enterprise. Knopf was so impressed by Ransom's activities that

he committed both his library and the firm's papers to the University of Texas.

Contemporaneous with the Knopf gift was the 1960 donation by Erle Stanley Gardner of his papers and library, one of the most complete records of a writing career ever made. When asked about his choice of repository, Gardner, the author of the Perry Mason series, acknowledged that he had been approached by several other universities but "had selected the University of Texas because of his friendship with Dr. [Merton] Minter [then chairman of the Board of Regents] and Park Street, a San Antonio lawyer with whom he

[had] been intimately associated in the Court of Last Resort for nearly 12 years." He continued, "My friendship with these men, plus the fact that I am an honorary captain in the Texas Rangers, is an association with Texas that makes me feel I am virtually a citizen of the state."[1]

Perhaps it helped that in consideration of the gift, Ransom agreed to re-create and maintain on permanent exhibition Gardner's study, which was moved from his Rancho del Paisano near Temecula, California, and now resides on the fourth floor of the Flawn Academic Center on the University of Texas campus.

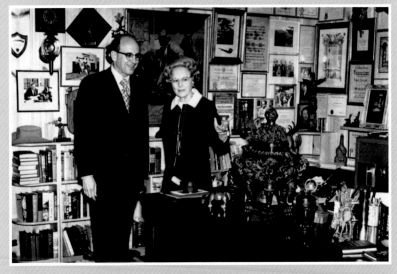

Mrs. Erle Stanley Gardner and University President Stephen H. Spurr in a replica of Gardner's study re-created in the Academic Center, 1972. Photograph by Frank Armstrong.

ments, and other personal papers could also shed light on the writing process and were of interest. Literary scholars who focused on the nineteenth and earlier centuries already used such materials to inform their research, and it was becoming clear that they would be equally useful to students of the modern age. Beginning in 1935, Charles Abbott had assembled at the University of Buffalo a collection of select contemporary poetry manuscripts that created what he called "a kind of laboratory where the study of that 'intellectual activity that gives birth to works themselves' may be encouraged."[7] Ransom may have been influenced by Abbott's efforts and the University of Buffalo's landmark Modern Poetry Collection. Ransom, however, greatly amplified the idea, acquiring intact the entire corpus of a writer's papers rather than just single manuscripts. Because of Ransom's foresight, combined with the scope and scale of his collecting, the literary archive rather than the single showpiece manuscript or rare book became the new focus of institutional collecting, not just in Texas but at institutions across the country.

Ransom, those who knew him have observed, was blessed with a singular power of persuasion. Stocky and unassuming in appearance, serious and low-key in demeanor—but nevertheless indefinably charismatic—he became adept at charming money out of University regents and collections out of donors. Those who fell under his spell often remarked afterward that they had been "Ransomized," an effect that Ronny Dugger, one-time editor of the *Texas Observer,* believed to stem from the fact that Ransom "never really committed himself," thus allowing his listeners "to believe anything they wanted to believe."[8] A colleague once remarked that Harry Ransom seemed to have an infinite capacity to assume that the most impossible sort of thing is going to happen—and then proceed to make it happen—not worrying about the minutiae that trouble the 27½ cent minds.

In September 1957, the Rare Books Collection finally received the academic distinction Ratchford and Ransom had argued for when it became a joint faculty-library organization and Ransom was named its director. The following month, Ransom was promoted from dean of the College of Arts and Sciences to vice-president and provost of the University. As a top administrator, he was now in a position to lobby the regents directly for funding that would support his goal of creating a university of the first class through growth of the library collections. He asked for $2 million and received a commitment of $1.5 million to build research collections for the 1958–1959 academic year. He also added three faculty members to the staff of the Rare Books Collection— the young scholar William B. Todd to be in charge of bibliographical research, D. H. Lawrence scholar F. Warren Roberts to develop the modern British literature collections, and James S. Meriwether to head acquisitions in American (especially Southern) literature.

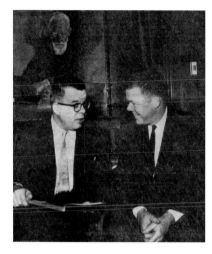

William Todd and F. Warren Roberts discuss a rare book beneath a portrait of George Bernard Shaw, ca. 1961. Unidentified photographer.

Ransom's bold vision for the University's libraries extended beyond the Rare Books Collection. He was also intent on improving the educational experience for undergraduates through an enhanced library program suited to their needs. Ransom believed that the closed-stack library system in place at the University tested "scholarly pertinacity, depth of bibliographical penetration, breadth of comparative studies, and sophistication of intellectual judgment. In other words," he claimed, "it is unusable by freshmen and sophomores."[9] He was determined to change the library environment, which he thought suffered from a "quarter-century of denial" of the needs of undergraduates and "the faculty's quiet surrender to textbook selections and cheap reprints."[10] In March 1958, the Board of Regents authorized construction of a new Undergraduate Library and Academic Center as part of the library development program. An advance description of the Academic Center in the spring 1958 issue of the *U.T. Record*[11] promised undergraduates a 200,000-volume browsing library of new books, advisory programs, teaching experiments, and teaching exhibitions—all under one, air-conditioned roof. Students soon came to refer to the Academic Center as "Harry's Place."

The new Academic Center would also provide a home for the Rare Books Collection, which continued to command Ransom's attention and stewardship. In 1958, Ransom sent a request to University President Logan Wilson to change the name of the Rare Books Collection to the Humanities Research Center. He claimed that "the recommended title reflects more accurately the present character of this activity and its future development."[12] The name change became effective on September 1.

Two years later, Harry Ransom became president of the University of Texas, serving in this capacity until 1961, when he became chancellor of the University System. He appointed F. Warren Roberts to be director of the Humanities Research Center, though Ransom remained closely involved in the Center's acquisitions. Faced with space constraints, Ransom and Roberts agreed to divide the rare book and manuscript collections between the Main Building and the new Academic Center. These collections were watched over by librarians June Moll and Ann Bowden, respectively. The Stark Library, housing pre-1850 rarities, opened in a renovated space in the Main Building on September 3, 1963. The Academic Center, housing on its top floor the Humanities Research Center's modern manuscript and book collections, opened on September 23, 1963. The three lower floors, containing 60,000 books, were designated as the Undergraduate Library, a facility designed to encourage independent study and educational activity for undergraduates.

Exhibition catalog *A Creative Century: Selections from the Twentieth Century.* The exhibition celebrated the formal dedication of the Academic Center on November 25, 1964.

Prior to the opening of the new Academic Center, Ann Holmes, fine arts editor of the *Houston Chronicle,* praised the University's library development in her article "A Texas Brag for the Books":

Beat a huge drum and the Longhorn football team roars in. But there are no sound effects, no yell leaders for what may be the University of Texas' greatest claim to fame. Last year, the University library nosed out proud Harvard in expenditures for rare books and manuscripts. Besides the $1.2 million spent, another $500,000 worth of rare books was donated. Next week, a big squarish building will open in the heart of the original 40-acre campus. It represents both ends of the library spectrum.[13]

Listing the many treasures to be found within both the Stark Library and the Humanities Research Center, Holmes concluded that with the opening of each, "the University of Texas hangs out a light in the window for scholars and writers on campus and everywhere. It should be the pride of Texas that it burns with a particular brilliance."

The Academic Center was formally dedicated on November 25, 1964. For the occasion, the Humanities Research Center mounted an exhibition called *A Creative Century.* The accompanying catalog, widely distributed and reviewed, attracted worldwide attention to the Center. In its introduction, Warren Roberts succinctly characterized the institutions housed in the new Academic Center:

The nature of both the Undergraduate Library and the graduate research collections for the study of twentieth-century literature has been determined by the requirements of scholarship. Here is no museum of dead matter, but rather the living spirit of the century, fashioned by the men whose words have so distinguished its first decades.[14]

SOLD TO TEXAS

The year 1958 and the decade after mark the first high point of collection development for the Humanities Research Center. Between 1958 and 1969, the regents made available more than $17 million for the development of the University's research collections. Ransom recruited to the arduous task of library building an international network of helpers that included book and manuscript dealers, faculty, and even some authors. It was Ransom, however, who was principally responsible for two of the Center's earliest substantial purchases.

In July 1958, the Center finally succeeded in purchasing the library of Edward Alexander Parsons, which Ransom had been trying to acquire for years. Parsons was a New Orleans attorney, scholar, and bib-

COLLECTING THE IMAGINATION

Several of Ransom's preferred booksellers at the opening of the Academic Center, 1963. Pictured from the left are Jake Zeitlin, James Drake, Frances Hamill, Bertram Rota, Margie Cohn, Lew David Feldman, and Franklin Gilliam. Unidentified photographer.

Mr. and Mrs. Edward Alexander Parsons, whose library was purchased by Ransom in 1958. Unidentified photographer, not dated.

liophile who had assembled a collection of 40,000 volumes and 8,000 manuscripts over a period of sixty years. The collection had strengths in Americana, classics, fine printing and binding, Bibles, and European history and literature, providing a strong base for the fashioning of a major research center. When the acquisition was announced in October, the *Houston Chronicle* noted that it was Ransom "who kept the trail hot between Austin and New Orleans for several years, talking with Mr. Parsons . . . about the potentialities of the university as a great research center in the humanities."[15] Even at this early date, Ransom was on message, noting to the press that "we want this to be a working library, not a museum," and issuing an invitation to "students, scholars, writers, historians and the general public . . . to make use of it."

The first installment of the Center's most defining acquisition arrived on the heels of the Parsons library in the fall of 1958 without anyone at the University having a precise idea as to the treasures it held. T. E. Hanley's collection of books and manuscripts of modernist writers proved to be rich in the printed and manuscript works of D. H. Lawrence, Oscar Wilde, James Joyce, Dylan Thomas, George Bernard Shaw, Ezra Pound, T. E. Lawrence, Samuel Beckett, and other literary

THE T. E. HANLEY LIBRARY

Seldom have institutional and private collecting goals coalesced as fortuitously as those of the Ransom Center and T. E. Hanley, industrialist and philanthropist of Bradford, Pennsylvania. In the mid-1950s, Harry Ransom was deeply involved in defining and shaping the research collections at the University with a keen eye on twentieth-century materials. Ed Hanley, on the other hand, had been buying books and manuscripts by James Joyce, Ezra Pound, D. H. Lawrence, T. E. Lawrence, Samuel Beckett, George Bernard Shaw, and others, as well as contemporary art, since his school days at Harvard beginning in 1915.

Thus it was with great excitement and expectation that Ransom first wrote to Hanley in September 1954: "Dear Sir: By an almost uncanny coincidence I have been brought acquainted with your great modern collections twice within the past few weeks . . . Our concern at Texas is to supplement the very great libraries (John Henry Wrenn, George Aitken, Miriam Lutcher Stark, and Everett DeGolyer) which cover earlier periods of English and American literature. With this purpose in mind—and with a resolution to make here a live center for research and writing, not merely a museum of books—we have begun collections of twentieth-century literature."[2]

Correspondence between Ransom and Hanley continued, centering first on Hanley's Lawrence materials but later on his entire library. With the assistance of James F. Drake, the New York bookseller who also helped shepherd to Texas the Alfred A. and Blanche W. Knopf library, negotiations were concluded, and the bulk of Hanley's library was purchased in July 1958. A second portion, consisting mainly of manuscript collections, was purchased in 1964. The manuscripts in the Hanley library form the cornerstone of the Ransom Center's twentieth-century literary holdings.

In 1969, Hanley's books and manuscripts were supplemented by a bequest of fifty works of literary art, including a bust of Louis MacNeice by Hugh Oloff de Wet, a charcoal drawing of T. S. Eliot by Wyndham Lewis, oil portraits of James Joyce by Frank Budgen and of G. B. Shaw by William Rothenstein, and Eric Gill's stone sculpture *The Fifth Station of the Cross*.

NORMAN BEL GEDDES COLLECTION

The library, professional archive, and personal files of Norman Bel Geddes, one of the most versatile and influential designers of the twentieth century, were acquired in 1959 by the Ransom Center with the support of the Edgar G. Tobin Foundation of San Antonio.

A pioneer in stage design, Bel Geddes was involved as writer and/or designer in more than one hundred plays, motion pictures, and other theatrical performances, ranging from the opera to the circus. His designs for *The Divine Comedy* (1921) and *The Miracle* (1923) are classics, but they are no more influential than many of his less widely known works.

Apart from his interest in the stage, Bel Geddes had a distinguished career in other fields. He designed the General Motors "Highways and Horizons" exhibit and "Futurama" for the 1939 New York World's Fair; master plans for the city of Toledo, Ohio; display windows for department stores; and kitchen ranges. He was responsible not only for his own tradition of functionalism but also for a variety of specific creations, including typewriters, cigarette cases, poleless tents, and battleships.

The Bel Geddes collection contains close to a quarter of a million items, including more than 2,500 technical drawings, 2,000 renderings, 5,000 sketches, 6,000 books, 5,000 photographs, and Bel Geddes's entire office files detailing the design and production of nearly 1,000 different projects. Among other materials are lighting plots and designs, musical recordings, and five stage models, including those for Sidney Kingsley's *Dead End* (1935) and Franz Werfel's *The Eternal Road* (1935), directed by Max Reinhardt in 1937. The theater, architecture, engineering, warfare, industrial method, and pure design are all represented in the library and archives that Bel Geddes created over a fifty-year career.

Norman Bel Geddes's model "Futurama, City of Tomorrow," created for the 1939 New York World's Fair. Photograph by Richard Garrison. Courtesy of Bel Geddes estate.

notables. The Hanley collection became the core of the Center's modern manuscript and book holdings and is exemplary of the Center's emphasis on collecting contemporary works and focusing on the manuscripts and other materials that precede the published work. Other notable acquisitions that year, suggestive of the breadth of Ransom's collecting ambitions, included the archive of the American theatrical and industrial designer Norman Bel Geddes and the Messmore Kendall collection of materials related to the eighteenth- and nineteenth-century English and American theater.

Much of Ransom's broad vision for collection development can be discerned through his correspondence with bookseller Lew David Feld-

man of the House of El Dieff. Feldman was a newly established American book dealer specializing in mystery and detective fiction when he began to work with Ransom in 1956. Early purchases from Feldman included manuscript collections of Edmund Blunden, Christopher Morley, James Branch Cabell, and Nellie and Frank Harris, and libraries of mystery fiction and criminology compiled by Arthur Conan Doyle and Frederic Dannay (who cowrote with Manfred B. Lee under the pseudonym Ellery Queen). A December 10, 1957, letter from Ransom to Feldman suggests that Feldman was given a great deal of latitude in seeking out and recommending prospective acquisitions but also that Ransom had clear collecting parameters in mind:

I have been thinking about our plans for fortifying the major authors (although you will remember that I am going to be mainly concerned with definitive collection of minor people) . . . In the general plan, as I see it, we should move along a very wide front. The exceptions which I would make are only those unlikely to arouse much interest among graduate and undergraduate students or those who simply could not be built up effectively and economically in Texas. For instance, I would be completely disinclined to buy a small cache of Emily Dickinson papers. Important as she is, her manuscripts belong at Harvard, not at Texas. A distinguished collection of Dickinson books and criticism, however, would interest me immediately.[16]

Feldman became the American dealer most closely associated with the Center, and it was soon assumed that any successful bid by Feldman at New York and London auctions meant that the lots had gone to Texas. Feldman, on Ransom's instructions, was soon setting purchasing records. In June 1960, he bought half a sale at Sotheby's, including all the lots of a T. E. Lawrence collection. He then purchased most of a charity sale at Christie's, including a manuscript of E. M. Forster's *A Passage to India* for £6,500. The price of the Forster manuscript was nearly three times the previous English record for a modern manuscript. Feldman broke the record again in 1963 when he purchased for the Center the original manuscript of Joseph Conrad's novel *Victory* for $21,000. A few years later, Feldman's successful £34,000 bid for a commonplace book that had belonged to the poet Robert Herrick set a new auction record for a seventeenth-century manuscript, again on behalf of Texas.

Feldman's presence in the auction rooms was often unwelcome, at least to other book dealers. Charles Hamilton, in his 1981 exposé, *Auction Madness*, was scathing in his characterization of Feldman:

The ability to bilk one's clients at auction is a fine art, make no mistake about it. To succeed for a lifetime without detection or exposure, the auc-

tion-buying crook must have the cunning of a polecat, the ethics of a Gabon viper, and the acquisitive drive of a dung-beetle. All these feral qualities were uniquely fused in the late Lew David Feldman, a rare book and manuscript dealer who operated under a firm name devised from his cutely bastardized initials—The House of El Dieff.[17]

Whatever Ransom's or Warren Roberts's private reservations about Feldman might have been (Roberts is reported to have thought Feldman pretentious), both relied on Feldman's willingness to let the Center, in effect, buy on installment, allowing Ransom time to amass funds for purchases. Writing in 1958 to James Meriwether, who was building for the Center a collection of Southern writers, Feldman reported that "we have made arrangements with Dr. Ransom to carry the U.T. account running upwards of $100,000.00, so we feel prepared to extend you any reasonable deferred billing to help you achieve your ends."[18] By 1970, Ransom owed the House of El Dieff more than $3 million.

For British and European author archives, the Center relied most heavily on the London firm of Bertram Rota Ltd. From the firm, the Center acquired approximately one hundred author archives between

1959 and 1971, including a huge collection of Ezra Pound materials, which contained inscribed copies of Eliot's *The Waste Land;* thousands of letters, notebooks, and photographs; hundreds of books from Pound's personal library; manuscripts; and proof sheets. Other acquisitions included a large portion of the papers of Romanian Princess Marthe Bibesco and the personal papers of several writing dynasties, such as Theodore Francis, Llewelyn, and John Cowper Powys and Edith, Osbert, and Sacheverell Sitwell.

The Humanities Research Center did substantial business with other booksellers, most notably Franklin Gilliam's Brick Row Bookshop (Austin), the Gotham Book Mart (New York), the Jenkins Company (Austin), the firm of Hamill and Barker (Chicago), and Marguerite A. Cohn's House of Books (New York). It was, in part, through Margie Cohn that Ransom arranged one of the earliest author visits to the University. It became one of Ransom's strategies to invite writers to Texas as guest lecturers, hoping they would then go forth as ambassadors of the University. Ransom wrote to Cohn on December 10, 1957, asking for assistance in arranging some of the more "personal points" of a planned visit by T. S. Eliot:

I know that a great many such visitors are bored stiff, overfed, wagged to death by adoring hosts and generally made miserable by academic and literary hero-worship . . . Our main interest is to arrange a significant and tasteful occasion on which the Modern Literature Collection, which will be centered in his name, may be opened to the public.[19]

T. S. Eliot's *The Waste Land,* inscribed by Eliot to Ezra Pound. Eliot calls Pound *"migglior fabbro,"* "the better maker."

THE HELMUT GERNSHEIM PHOTOGRAPHY COLLECTION

Helmut Gernsheim studied the history of art at Munich University and, from 1934 to 1936, photography at the Bavarian State School of Photography in Munich. In 1937 he moved to London and as a freelance photographer became known for his objective portraits and photographs of architecture and sculpture.

Gernsheim began collecting aesthetically and historically important photographs and related materials in 1945 at the suggestion of Beaumont Newhall, the American photo-historian. By 1963, with the assistance of his wife, Alison, his efforts had resulted in the formation of the largest photo-historical archive in private hands, totaling 33,000 nineteenth- and twentieth-century photographs, 4,000 photographic books and albums, 350 pieces of photographic equipment, and assorted manuscripts and autograph letters from leading photographers.

His most important discoveries relating to the origin of photography included the First Photograph, taken by Joseph Nicéphore Niépce (ca. 1826); the original manuscript on the invention of heliography, sent by Niépce to the Royal Society and to King George IV of England; and one of the two existing 1827 prints from the etched plate of Cardinal d'Amboise, the first photomechanical reproduc- tion. In 1948 Gernsheim rediscovered the photographic work of Charles L. Dodgson (Lewis Carroll), five of whose ten known albums, totaling 365 photographs, are in the Gern- sheim collection.

By the early 1960s, the collection had reached unmanageable propor- tions, and the Gernsheims sought an institution to purchase and maintain it. Finding little interest in England or Europe, the Gernsheims shipped more than one thousand items to the United States for display at the Detroit Arts Festival in 1963. The Ran- som Center purchased the collection while it was on exhibit in Detroit.

T. S. Eliot at the University of Texas, 1958.
Photograph by United Press Photo.

T. S. Eliot arrived in Austin for a two-day stay on April 21, 1958, and gave a reading in the University's Gregory Gymnasium the following evening. That morning a press conference for Eliot was held in the Wrenn Library, and the Eliot Modern Literature Collection (an interim moniker for what would become the Humanities Research Center), featuring an exhibition of Eliot's works, was opened to the public.

Other noted author-ambassadors enlisted by Ransom included Hec- tor Bolitho, John Lehmann, and Cyril Connolly. Bolitho, reporting back to his fellow Australians after a visit to Austin, noted that the expatriation of so many British writers' manuscripts to Texas was jus- tified "because these Texans respect their distant heritage and have a passionate wish to absorb 'culture.' This yearning to understand and be understood by the world beyond their own vast frontiers is a new and healthy sign of their intellectual maturity."[20] It is no coincidence that the Center now houses these writers' papers, some purchased and oth- ers donated.

Although the clear focus of collecting at the Humanities Research Center was in the modern period, there were a number of notable ac- quisitions from earlier eras. A fifteenth-century manuscript of Chaucer's *Canterbury Tales* (the Brudenell-Cardigan copy) was purchased by H. P.

Kraus for Texas at a Sotheby's auction in 1959. In 1968, Texas bought a collection of more than 1,350 volumes of predominantly eighteenth-century works by and relating to Voltaire compiled by the British collector Desmond Flower. Ransom also initiated a number of discipline-based collection development programs that formed the foundation of the Center's rich holdings in the history of photography, performing arts, architecture, and science.

The library's enhanced acquisitions program under Ransom benefited not just the Humanities Research Center but other campus special collections as well, most notably the Barker Texas History Center (now the Center for American History) and the Benson Latin American Collection. Book purchases were also made for other University of Texas System libraries.

1965 TOWER FIRE

A fire broke out on the twentieth floor of the University Tower on August 10, 1965, damaging and destroying parts of the Humanities Research Center's theater arts holdings. Four rooms of books from the theater arts collection were almost completely destroyed, and smoke, heat, and water caused additional damage to materials housed on other floors. Among the damaged and destroyed materials were many of the personal artifacts of famed escape artist Harry Houdini; a collection of P. T. Barnum circus posters; materials from the collection of producer Robert Downing, including scene designs, stage plans, costume sketches, and Downing's personal scripts of the plays he produced by Tennessee Williams; and parts of the collection of renowned designer Norman Bel Geddes.

According to a student reporter's account, Frances Hudspeth, Ransom's executive assistant at the Humanities Research Center, attempted a brave rescue of the endangered collections:

"Where is the fire?" Mrs. Hudspeth asked. She was told the twentieth floor, and she said, "My books are up there," and immediately punched the twentieth-floor [elevator] button. When the elevator arrived there and the doors opened, smoke gushed into the car. An occupant pushed the first-floor button, the car shot down, and the occupants got out safely.[3]

Sparks from welding work on air-conditioning equipment ignited the fire, which burned for more than two hours as sixty firefighters fought the blaze. There was no alarm or sprinkler system in the Tower, which housed many of the rare books and manuscripts in the Humanities Research Center's collections.

Dr. Frederick Hunter, the Center's curator of theater arts, remarked that the damaged and destroyed materials were "absolutely irreplaceable."[4]

Special edition of *The Summer Texan*, reporting on the Tower fire of 1965

HISTORY OF SCIENCE

"In an age of atomic bombs, space sat-
ellites, and revolutionary discoveries
in genetics, the study of the history of
science has become one of the fast-
est growing subjects in the liberal arts
curriculum." With this statement in
an unsigned press release, the Center
announced in 1963 the purchase of the
libraries of Herbert M. Evans, Sir John
Herschel, and Owen W. Richardson and
its ambition to build a comprehensive
History of Science collection.

From the beginning, Harry Ransom
envisioned it as a physically separate
collection, and in the late 1960s he
sought the support of the Board of
Regents to secure space for the collec-
tion elsewhere on campus in the Sid
Richardson Hall complex. He was unsuc-
cessful, and the collections acquired
throughout the 1960s under the History
of Science rubric are now housed largely
between the Ransom Center and the
Center for American History.

NOTABLE HIGHLIGHTS INCLUDE:

THE SIR OWEN RICHARDSON
COLLECTION OF THE ATOM, including
the personal papers and library of Eng-
lish physicist and Nobel Laureate Sir
Owen W. Richardson. Richardson's most
important work was concerned with the
emission of electrons from hot bodies,
a subject to which he gave the name
"thermionics" and for which he was
awarded a Nobel Prize in 1928.

THE HASKELL F. NORMAN
COLLECTION, consisting of approxi-
mately 1,500 works on the biological
and physical sciences from the six-
teenth to the twentieth century, pur-
chased by the Center between 1968 and
1970 with assistance from the Sid W.
Richardson Foundation of Fort Worth,
Texas.

THE HERSCHEL ARCHIVE, comprising
journals, correspondence, mathemati-
cal manuscripts, photographic work,

and scientific memoirs collected by the
astronomer Sir John F. W. Herschel. The
archive also contains a wealth of infor-
mation on members of the Herschel
family, including John's father William
Herschel, discoverer of the planet Ura-
nus, and his aunt Caroline Herschel,
another noted astronomer.

THE PAPERS OF CHARLES PERCY
SNOW, the English scientist and novel-
ist, purchased by the Ransom Center
between 1960 and 1979. Among the
book-length manuscripts is his cel-
ebrated lecture given at Cambridge
University in 1959, "The Two Cultures
and the Scientific Revolution."

THE C. L. LUNDELL BOTANY
COLLECTION, consisting of six thou-
sand books, many of which derive from
the library of Oakes Ames, and a sig-
nificant aggregate of manuscripts and
journals dealing with plant taxonomy,
systematic botany, gardening, and
cultivation.

Distinguished guests at a luncheon
announcing a $2 million gift from the Sid
W. Richardson Foundation of Fort Worth,
which enabled the University to expand its
collection in the history of science, 1969.
Seated clockwise from the left are Frank
C. Erwin Jr., Lyndon B. Johnson, Mrs. John
Connally, Harry Ransom, Perry Bass, John
Connally, and Mrs. Perry Bass. Unidentified
photographer, Center for American History,
the University of Texas.

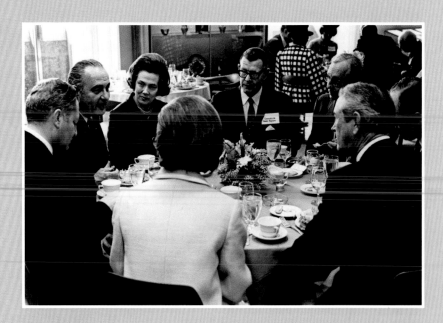

Under Ransom's leadership, the Humanities Research Center had a vigorous publications program. In 1964, the University's *Library Chronicle* featured a bibliography of the Center's publications from 1958 to 1963, presenting an impressive list of the Center's exhibition catalogs; a trio of poetry publications that led to the establishment in 1962 of the Tower Series; publications that grew out of conferences, symposia, lecture series, and individual scholarly research; and listings of books and manuscripts from the collections.[21] Edwin T. Bowden, the compiler of the bibliography, concluded that the Center had, through its publication program, amply fulfilled its responsibilities to share its collections with a larger public.

Many of the forty-eight publications listed in Bowden's bibliography were designed by Kim Taylor, who began his association with the Center with the 1958 publication of a cycle of love poems by D. H. Lawrence, titled *Look! We have Come Through*. Ransom hired Taylor in 1960 as associate editor of the *Texas Quarterly* and consultant to the University publications program. Born in India to English parents, Taylor had worked as an editor of *Graphis,* an international graphic arts magazine based in Zurich, Switzerland. He had also published small editions of finely printed books under the Ark Press imprint in England. Within a short time, Taylor's work was winning design awards. *The Craft and Context of Translation* (1961) and *Poor Heretic: Poems by Kenneth Hopkins* (1961), both Humanities Research Center publications, were included in the American Institute of Graphic Arts' *Fifty Books of the Year* exhibition for 1962, selected from more than eight hundred entries. In 1963, Taylor's Tower Series for the Center won the Dallas Museum of Fine Arts Award for general excellence in design and typography. The Tower Series, as Edwin Bowden phrased it, "continued the hesitant steps toward a poetry series that would make available the work of poets with whom the Center had some close relationship."[22] Original verse by Frederic Will, Richard Emil Braun, William Burford, Robert D. Fitzgerald, Roger Shattuck, Edward Dahlberg, and Alberto de Lacerda, as well as a selection of letters by Friedrich Hölderlin, Arthur Rimbaud, and Hart Crane all appeared in the series between 1961 and 1969. The Center also created the Tower Bibliography Series, which ran from 1961 to 1968. This series combined a full, descriptive bibliography of an author's published work with a comprehensive listing of the University's manuscript holdings for that author, leading one reviewer to dub them "parabibliographies."

Kim Taylor worked at the University until 1969, when he moved back to England to resume the Ark Press imprint. He continued to

Cover of the 1971 bibliography of publications by the Humanities Research Center, compiled by Edwin T. Bowden and designed by Kim Taylor

design books for the Center, however, notably those in the Tower Poetry Series, until 1971, when he concluded his association with the University with his design of *The First Hundred Publications of The Humanities Research Center of The University of Texas at Austin*. Of the works featured in the book, Taylor had a hand in the design and production of thirty-eight. Al Lowman, in his *Printing Arts in Texas,* wrote about Taylor: "In design he plotted his own individualistic course. His work is readily recognizable, strongly personal, and strongly stated. Nothing like it had been seen previously in Texas, nor has its like been seen since."[23]

In addition to the books published by the Humanities Research Center, Ransom supported other publications at the University. Perhaps his best-known initiative was the *Texas Quarterly,* founded in 1958 and published until 1978. Designed to appeal to the general literate reader and, despite its name, to reach beyond regional concerns, the periodical featured articles by leading scientists, novelists, poets, critics, scholars, statesmen, businessmen, architects, photographers, and artists. Special issues on Mexico, Spain, Italy, Britain, Australia, and South America, as well as supplements issued on other topics, have become collectors' items.

In 1970, anticipating completion of a new seven-story Humanities Research Center building in which many of the University's rare book and manuscript collections were to be consolidated, *The Library Chronicle* of the University of Texas at Austin (initiated in 1944 to report on library affairs at the University, but halted for two years beginning in 1968) reappeared under new editorial leadership and in a revised format. Edited by Warren Roberts and designed by William R. Holman, the *Chronicle* featured pictorial wrappers and was more generously illustrated. In addition to articles about research materials and library affairs, it introduced a number of regular features, including a column titled "Books at Texas," author portraits, and materials from the collections. Although editors and formats changed over the years, *The Library Chronicle* remained under the direction of the Humanities Research Center until it ceased publication in 1997, concluding a fifty-year tradition of interpreting and promoting the University's library holdings.

GROWING REPUTATION

Although many other American university libraries were building up their rare book and manuscript collections in the 1960s, the sheer volume of materials coming to Texas and the prices paid for them earned the University an international reputation. Response, however, was not

Covers of six volumes published in the
Center's Tower Series, designed by Kim
Taylor, 1962–1967

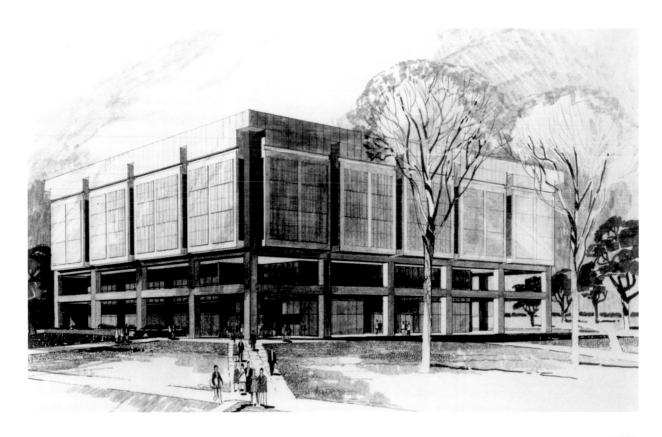

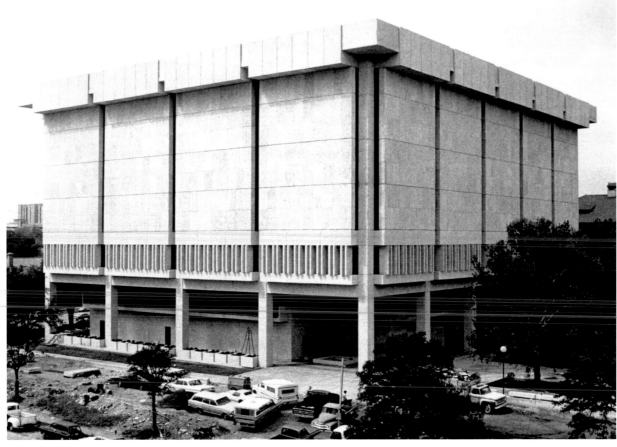

COLLECTING THE IMAGINATION

wholeheartedly affirmative. Accusations that Texas's mass purchasing efforts were quickly raising prices circulated freely in the press. Noting the increased value of modern manuscripts in contrast to twenty or thirty years earlier and in response to Texas's successful bids (through Feldman) at an English auction, bibliographer Percy Muir offered, in defense of Texas, a straightforward explanation of market economics:

[E]ven if Texas were the bulldozing Moloch it is commonly represented to be, the hard fact is that when Mr. Feldman or another makes a successful bid on this or any other university's behalf there is always an underbidder . . . another experienced professional antiquarian bookseller who bid . . . only one notch lower before bowing out.[24]

British bookseller Bertram Rota offered a more pointed defense of Texas's effort:

After a long period of comparative quiescence the University of Texas libraries faced their commitment to provide one of the major research collections in the United States . . . The aim is to serve the vast population of an area of the United States which has not easy access to the riches of the libraries of either coast, and to assemble in one place so representative a collection of the literary work of our time that students anywhere may count upon finding in Texas sources for study through generations to come . . . So comprehensive a programme, aiming at early results, of course has its pitfalls, and in reaching for the stars ruts have sometimes been tripped over . . . but by and large we are watching an ambitious plan courageously executed. In the view of the Chancellor [Ransom] the work will be judged in a century or two, and this observer does not suspect that the flaws will then obscure the gem.[25]

In 1964, British journalist William Rees-Mogg attributed a nearly 50-percent increase in British rare books prices at auction to rising demand from libraries, particularly American libraries. He cautioned British universities that "this very rapid rise in prices marks the fact that this is the last decade in which it is at all possible to form any sort of proper university collection of English literature, and the opportunity is already slipping fast away. The University of Texas has been taking it—we have not."[26]

As British institutions dismally watched the rapid growth of American special collections and the migration of English writers' manuscripts from their homeland, British archivists and historians began to press their government to enact stronger export licensing laws and to encourage their own universities and national libraries to collect the pa-

OPPOSITE PAGE, TOP
Concept drawing of the new building for the Humanities Research Center, not dated

OPPOSITE PAGE, BOTTOM
The Center's new building under construction, ca. 1971. Unidentified photographer.

pers of contemporary British writers. In 1960, librarian and poet Philip Larkin helped establish a committee to provide funds to encourage the purchase of contemporary British writers' papers by British institutions. The committee did support the purchase of some contemporary writers' collections, though the migration continued on a large scale.

In 1969, British author and publisher John Lehmann wrote an article about his visit to the Humanities Research Center for the *Times Literary Supplement*. He concluded:

I cannot see what injury is done by the export of British literary archives to institutions in the United States of America; institutions which share a common heritage of language and civilization with us, and which have the resources to care for them in the most devoted way. It is true that the collecting zeal of the Humanities Research Centre (and of other American university institutions) has awoken British institutions to the need for finding funds to keep our archives on this side of the ocean; but they were fast asleep until Texas awoke them, and it is still not true that English manuscripts can automatically find an English buyer. In my opinion, the English-speaking world is one.[27]

Just two weeks after Lehmann's article appeared, Jenny Stratford, then Assistant Keeper of Manuscripts at the British Museum, published an analysis of the manuscript market in the 1960s. Citing examples of Texas acquisitions and prices paid in the course of the decade, Stratford argued that the "aggregate numerical strength and aggregate purchasing power" of North American institutions is just one reason for the migration of manuscripts. "The decision to specialize in this kind of material," she wrote, "is heavily influenced by the attitude, still much more usual among North American departments of literature, that living authors are suitable subjects for postgraduate or other studies."[28]

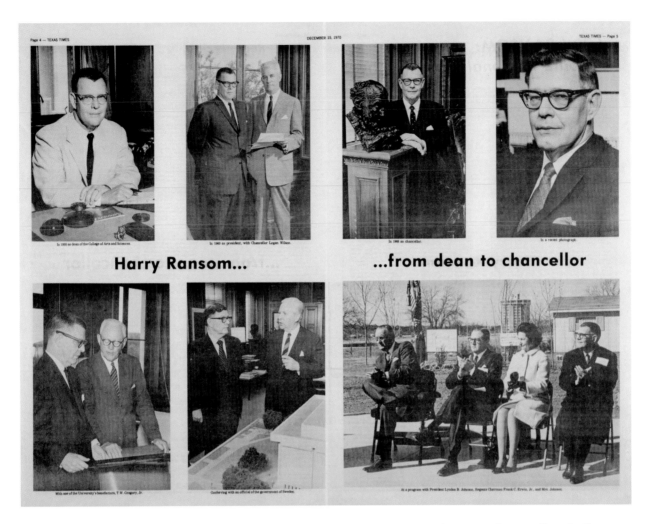

Page 4 — TEXAS TIMES

DECEMBER 15, 1970

TEXAS TIMES — Page 5

In 1953 as dean of the College of Arts and Sciences.

In 1960 as president, with Chancellor Logan Wilson.

In 1966 as chancellor.

In a recent photograph.

Harry Ransom... ...from dean to chancellor

With one of the University's benefactors, T. W. Gregory, Jr.

Conferring with an official of the government of Sweden.

At a program with President Lyndon B. Johnson, Regents Chairman Frank C. Erwin, Jr. and Mrs. Johnson.

Commemorative spread honoring Harry Ransom upon his retirement as chancellor of the University of Texas System, printed in *Texas Times* on December 15, 1970

British writer and publisher John Lehmann, 1960. Photograph by Hans Beacham.

Fabio Licino's plan of Rome, "Urbis Romae Descriptio" (Venice, 1557), was part of a large collection of maps and globes offered for sale in 1969 by the New York bookseller Hans P. Kraus. In typical fashion, Ransom bought almost everything in the catalog, with Lew David Feldman serving as agent.

Texas's activity must be judged in the context of general patterns of growth at other institutions of higher education in the 1950s and 1960s. David Boroff noted in the *Saturday Review* that Texas, "long a marginal institution, is making a concerted bid to become an institution of the first rank" in perceived competition with Harvard.[29] Already ranked among the top twenty universities of the time, Texas's ambition was to move into the top ten, an effort viewed outside the state somewhat churlishly. Boroff noted, "There are even those who view with suspicion the University's zeal in begging, borrowing, and buying one of the country's most imposing manuscript collections—as if it were some kind of absurd presumption for U.T. to own Henry James and T. S. Eliot manuscripts!" Citing Texas's progress in desegregation, an articulate and vigorous student newspaper, a faculty in transition from the old Texas to the new, and a "superb" library collection whose manuscript component ranked in the top five, Boroff concluded that, despite an "obsession with self" that made Texas "so persuaded of its virtue, so sensitive to criticism, and so unable to tolerate ambiguity," Texas was nevertheless "a place to watch."

Lee Minoff, in the *London Observer,* put the University's growth into an English context:

COLLECTING THE IMAGINATION

While universities in Britain are expanding at a rate that alarms conservative dons and the Kingsley Amis "more-means-worse" school, American higher-education is burgeoning without qualm . . . The U.S. State universities—financed by State legislatures and enormously aided by Federal grants—are the really big noises in this learning explosion and none makes the point more clearly than the University of Texas.[30]

Noting the campus's "energy and optimism" and the delight of British visiting faculty with the University's "salaries, facilities, and sun" (despite an undergraduate body "shockingly ignorant of basic facts" by English standards), Minoff credits the University's drive toward national status as beginning with President Logan Wilson and really taking off under Ransom's leadership. In the process, Minoff contributed greatly to the mythologizing of Texas's voracious appetite:

During Ransom's reign Texas has become the world's greatest repository of source material in twentieth-century British and American literature. U.T. has been gobbling up whole libraries, rare books, manuscripts, diaries and correspondence faster than they can be catalogued. In offices and corridors of a new $4.5 million undergraduate Library and Academic Centre—nicknamed "Harry's Place" by students—one sees harried librarians in pitched battle with crates and boxes overflowing with Sir Hugh Walpole, Ransom's latest coup. U.T. has become a terror of the book auctions in London and New York, acquiring more than half a million rare books and manuscripts in the past five years.

By 1969, the Humanities Research Center staff estimated that the Center housed 4 million manuscripts, 1.2 million books, and 2 million photographs. In 1970, Anthony Hobson listed the Humanities Research Center as one of thirty-two great libraries in the world, primarily on the strength of its twentieth-century holdings. "Texas is like an active volcano," he wrote. "It is impossible to tell in which direction it will erupt next."[31]

·

SPECIAL COLLECTION ROOMS

The Ransom Center has more than a dozen special collection rooms (several of which re-create authors' offices), featuring personal libraries, period furniture, collections of silver or china, paintings, and photographs.

After her success as associate editor of *Look* magazine in the 1940s, author and painter Fleur Cowles created and edited the stylishly innovative *Flair* magazine in 1950. The Fleur Cowles Room is inspired by her study in Albany, her primary residence in Picadilly, London.

The J. Frank Dobie Library contains the personal library, memorabilia, and furniture from the Austin home of Texas native, folklorist, author, and University of Texas English professor J. Frank Dobie.

The John Foster and Janet Dulles Rooms replicate the study and living room of the Dulles home in Washington, D.C., as it was during the time Dulles served as secretary of state under President Eisenhower. The room contains artifacts given to Dulles while Eisenhower was in office.

Perhaps the Center's most unusual room is the Erle Stanley Gardner Study. A full cabin-within-a-room, it replicates the detective novelist's workroom at his ranch home in Temecula, California. The walls of the room surrounding the cabin/study feature first editions of many of Gardner's books, honorary police badges, photographs, letters, and television scripts for *Perry Mason*.

Theater owner, civic leader, and philanthropist Karl Hoblitzelle dedicated the Esther Hoblitzelle Parlor to the memory of his wife. The parlor is furnished with silk wallpaper, carvings, and Chippendale furniture from the family home in Dallas, Texas.

The Ransom Center has dedicated a suite of three rooms to Tom Lea, the Texas writer and painter known for his landscapes and Texas-Mexican border art. The Tom Lea Rooms display examples of Lea's paintings, drawings, books, manuscripts, photographs, and memorabilia documenting his life.

The Lundell Library contains more than six thousand volumes of rare botanical books and journals, some dating from the eighteenth century, collected by Dr. and Mrs. C. L. Lundell. The colonial furnishings, many of which are antiques, were purchased by the Lundells in Williamsburg, Virginia.

The dominant theme of the Cora Maud Oneal Room is nineteenth-century French. The room includes a Gobelin tapestry (ca. 1800–1810), a magnificent Boulle center table (ca. 1810) and Boulle desk, and a Louis XV commode in satinwood with Sèvres plaques, trimmed in gold bronze.

Paintings by Kelly Stevens, William Henry Huddle, Valentin de Zubiaurre, Eugene Lepoittevin, and Angel Caraveille are displayed on the walls of the Kelly Stevens Room. Decorative arts in this room include pottery made by Stevens, a pair of Baccarat purple glass urns, silver, and china from Meissen, Berlin, and Dresden.

The Willoughby-Blake Room, established by Clara Pope Willoughby and her husband, Ray Willoughby, in memory of Mrs. Willoughby's aunt, Ruth Starr Blake, a direct descendant of James Harper Starr, who was secretary of the treasury for the Republic of Texas, includes in the Blake Collection Texian Campaign china (ca. 1840) and one of the finest private collections of silver by English silversmith Hester Bateman. Also on display in this room are items from the Mrs. E. E. Sheffield Collection, including an oblong mahogany Georgian banquet table (ca. 1780) and Hepplewhite chairs (ca. 1770).

NOTES TO TEXT

1. Unidentified author, 1947, Ransom Center collections.

2. *Library Chronicle* 4, no. 1 (1950): 55.

3. Ransom to Painter, March 10, 1949, Ransom Center collections.

4. Ransom to Maguire, March 14, 1957, Ransom Center collections.

5. Ransom to Wilson, April 18, 1957, Ransom Center collections.

6. Ransom, "The Collection of Knowledge in Texas," reprinted in its entirety in this volume.

7. Abbott, introduction to *Poets at Work,* 5.

8. Burns, *The Awkward Embrace,* 43.

9. Ibid., 56.

10. H. H. Ransom, "The Academic Center," 49.

11. *U.T. Record* 3, no. 4 (1958): 1–3.

12. Ransom to Wilson, August 22, 1958, Ransom Center collections.

13. Ann Holmes, "A Texas Brag for the Books," *Houston Chronicle,* September 15, 1963.

14. Roberts, introduction to *A Creative Century,* 5.

15. "Collection Adds to UT's Stature," *Houston Chronicle,* October 28, 1958.

16. Ransom to Feldman, December 10, 1957, Ransom Center collections.

17. Hamilton, *Auction Madness,* 19.

18. Feldman to Meriwether, October 13, 1958, Ransom Center collections.

19. Ransom to Cohn, December 10, 1957, Ransom Center collections.

20. Hector Bolitho, "The Liberal Arts Flourish in Texas," *The Auckland Star,* January 2, 1968.

21. Bowden, "Publications."

22. Bowden, *First Hundred Publications,* 7.

23. Lowman, *Printing Arts,* 33.

24. Percy Muir, "Moderns in the Auction Room," *Times Literary Supplement,* June 30, 1961.

25. Bertram Rota, "The Heart of Texas," *Times Literary Supplement,* July 14, 1961.

26. William Rees-Mogg, "Sellers' Market in Books," *The Sunday Times,* April 19, 1964.

27. John Lehmann, "John Lehmann on a Visit to the Humanities Research Centre, University of Texas," *Times Literary Supplement,* July 10, 1969, 758.

28. Jenny Stratford, "The Market in Authors' Manuscripts," *Times Literary Supplement,* July 24, 1969, 817.

29. Boroff, "Cambridge on the Range," June 20, 1964, 48, 65.

30. Lee Minoff, "The Super University of Texas," *London Observer,* February 14, 1965, 18, 28.

31. Hobson, *Great Libraries,* 310.

NOTES TO SIDEBARS

1. University News and Information Service press release, July 2, 1960.

2. Ransom to Hanley, September 10, 1954, Ransom Center collections.

3. Richard Cole, "Research Assistant Turns in Fire Alarm," *The Summer Texan,* August 10, 1965.

4. Susan Powell, "Theater Collection: Loss 'Irreplaceable,'" *The Summer Texan,* August 10, 1965.

YEARS OF
CONSOLIDATION

PART 3

THE HARRY RANSOM
HUMANITIES RESEARCH
CENTER, 1972–1988

Richard W. Oram

THE NEW BUILDING

After the unprecedented and explosive growth of the Humanities Research Center collections in the 1960s, the next decade and a half was, perhaps inevitably, a period of consolidation. The process began with the relocation of the Center and most of its collections into a new facility in 1971. The modern books and manuscripts flooding into the Academic Center and those in storage in the University's Tower and elsewhere, as well as the pre-1850 collections in the Stark Library, would finally be housed in a single facility. A 1965 fire in the Tower, resulting in considerable water damage to several theater arts collections, had made clear how vulnerable materials in makeshift storage could be.

Ransom and the University's Board of Regents began work on the funding and design of the building in the mid-1960s. The site selected was a parking lot on the corner of Guadalupe and 21st Streets, at the southwestern corner of the "Forty Acres," the original University of Texas campus. Jessen, Jessen, Millhouse, Greeven, and Crume, the same architects who had worked with Ransom on the Academic Center, were chosen to design the new building. It was to be a concrete structure seven stories high, nearly cubical, and outfitted with an attractive cladding of Texas Hill Country shell limestone. A large plaza occupied by live oaks and sycamores provided a pleasant, natural surrounding. One reporter called the building "a big white marble box . . . designed by a lover of Arab-style splendor."[1] Another remarked that "a visitor wandering in from the Mongolian steppes might be pardoned for mistaking it for anything from an aboveground missile silo to the emperor's royal handball courts."[2] The upper floors were primarily intended to house collections in a secure, climate-controlled environment and had small slit windows limiting the intrusion of light. Some believed that the design resembled a fortress and was intended to keep out student

agitators, although the campus saw only a handful of antiwar demonstrations in the late 1960s. The austerity of the building's exterior was matched by a dim and institutional outer lobby, embellished with brown mosaic tiles. Until the completion of the 2003 renovation, visitors could and frequently did enter the building without finding a clue as to what riches lay within.

At the end of 1971, the new Humanities Research Center was ready for occupancy, and teams of staff and students moved collection materials into the building. Some collections, however, including portions of the Stark Library in the Main Building and the J. Frank Dobie, Alfred and Blanche Knopf, and Edward Larocque Tinker libraries in the Academic Center, remained in the special rooms created for them. A reading room on the fifth floor of the new building, furnished with dark wood paneling, glass partitions, and green carpeting, was opened in February 1972. The building had been officially designated a classroom space to secure federal funding, and so the offices and classrooms of the Graduate School of Library Science occupied the fourth floor. At a late date in the design process, most of the bottom two floors was reserved for the University's Archer M. Huntington Art Gallery (later called the Blanton Museum of Art) to display the contemporary paintings donated by James and Mari Michener, removing the most prominent public spaces in the building from the Center's domain. The Humanities Research Center thus kept its original and distant exhibition space in the Leeds Gallery on the fourth floor of the Academic Center. The presence and prominence of the Huntington Gallery in the building created a blurring of institutional identity that persisted for three decades; casual visitors understandably but erroneously thought the art

Harry Ransom with a model of the Humanities Research Center's new building, late 1960s. Unidentified photographer.

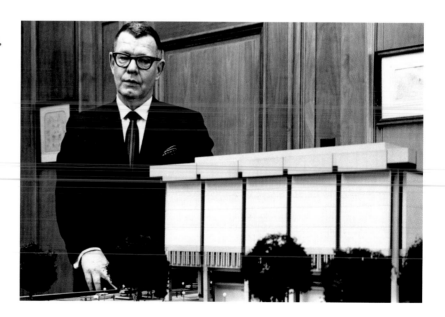

COLLECTING THE IMAGINATION

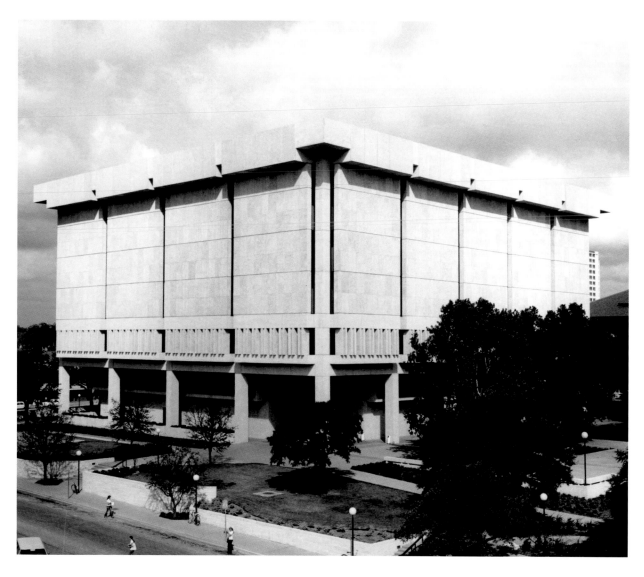

The Humanities Research Center
building, completed in 1971. Unidentified
photographer.

Tennessee Williams visiting the Humanities
Research Center reading room, November 2,
1973. Photograph by Frank Armstrong.

in the first-floor gallery was part of the Humanities Research Center collections.

Harry Ransom, retired from his position as chancellor, assumed the title of Director of Special Collections and occupied a spacious, window-lined office in the Tom Lea Room on the third floor of the new building. Frances Hudspeth, his capable and hardworking assistant who had played an indispensable role in planning and overseeing the details of the building's construction, passed away just days before it opened. F. Warren Roberts continued as the Center's director, with William R. Holman, the former director of the San Francisco Public Library, installed as librarian and David Farmer as assistant director.

Ransom's resignation as chancellor brought an end to the days of massive purchasing, and the acquisitions budget soon fell to $300,000, a fraction of what it had been in the mid-1960s. In the tough economic climate of the early 1970s, even that figure seemed excessive to Ransom's critics on campus, who felt that the former chancellor had

slighted the acquisitions budget for the University's General Libraries over the years. The library funding controversy continued through the tenure of President Stephen H. Spurr and spilled over into the presidency of his successor, Lorene Rogers, who for a time oversaw all the Center's acquisitions and further reduced its budget. In the fall of 1974, Harry Ransom was moved out of the office he had occupied for less than three years and into another office across campus, where he began work on a never-completed photographic history of the University. That same year, however, the regents formally recognized his achievements by renaming the new building (though not the institution itself) the Harry Ransom Center.

On April 19, 1976, Harry Huntt Ransom died unexpectedly of a heart attack while visiting relatives. Those who attended his memorial service heard eulogies lauding the ex-chancellor's construction programs, which had transformed the Texas campus, and his recruitment of first-class faculty (the so-called "Harry's Boys"), but most observers recognized that his true monument was the Humanities Research Center. Ransom had built one of the world's great research libraries in less than a quarter of a century. By the early 1970s, Ransom's "program for the library" had brought three-quarters of a million books and scores of major manuscript collections to the University. Kathleen Gee Hjerter, a curator of the art collection, recalled rooms "stacked to the ceiling with so many cardboard boxes that you had to walk sideways to get around. It was coming in so fast," she remarked, "that they could barely keep up with it."[3] Although Ransom firmly believed and often said that "a university library is not effective as a mere book mausoleum . . . There is no point in collecting materials not to be used,"[4] he generally left

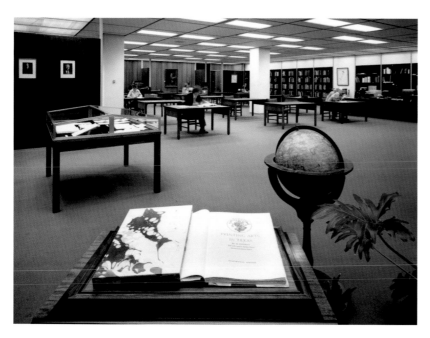

The fifth-floor reading room, ca. 1970s. A rare Mercator globe (1541) is in the foreground. Unidentified photographer, Center for American History, the University of Texas.

to others such practical matters as cataloging and servicing the collections. Gossip had it that the Center had acquired materials so quickly that unpacked collections were everywhere, record keeping was nearly nonexistent, and the institution had little idea what materials it housed. These exaggerations were not wholly without substance.

Fortunately, Herculean (and ultimately successful) efforts to organize the mass of materials were under way. Under the aegis of the University's General Libraries, a backlog cataloging project headed by Mary Beth Bigger organized for the Center the thousands of volumes in storage, including the contents of several bookstores purchased by Ransom and Warren Roberts. At the project's zenith, no fewer than fifty catalogers and assistants were on the payroll. The unit cataloged approximately a half million titles between 1972 and 1996, when the unit officially became a part of the Ransom Center. After 1976, books were cataloged using the new OCLC computer cataloging system. Beginning in the mid-1960s, the small manuscripts cataloging unit, headed by Eugene Lillard and later by John Kirkpatrick, began to painstakingly catalog manuscript holdings item by item onto notepads, and then transfer the information to individual catalog cards. The process of organizing a large collection of an author's papers sometimes took several years.

In this period, the Ransom Center's collections became more widely known, and use of the materials increased significantly. More and more researchers working on modern literature discovered that their projects would require a trip to Austin. British academics were sometimes unpleasantly surprised to find that the manuscripts of Edith Sitwell, Evelyn Waugh, and Elizabeth Bowen had been removed en bloc to—of all places—Austin, Texas. Upon arrival, these researchers were generally won over by the friendliness of the staff and the tame variety of Texas exoticism represented by Austin.

The comprehensive Bernard Shaw exhibition, curated by Shaw scholar Dan Laurence, in the Leeds Gallery, 1977. Photograph by Frank Armstrong.

COLLECTING THE IMAGINATION

CARLTON LAKE

Connoisseurship, passion, persistence, and good fortune combine to make a great collector. The career of Carlton Lake, the Ransom Center's executive curator of French literature emeritus, is illustrative of all these traits. A native of the Boston area, Lake made his first purchases at the Harry Bache Smith auction, at about the same time he graduated from Boston University in 1936. The most important of the items he purchased were the heavily revised proof sheets of Charles Baudelaire's "Les Litanies de Satan," which, along with other Baudelaire lots in the same sale, became the cornerstone of the Lake collection. During his three decades in Paris as a correspondent and freelance writer following the war, Lake was perfectly situated to acquire original art by Jean Cocteau, Henri Matisse, Valentine Hugo, Raoul Dufy, André Derain, Pablo Picasso, and the Surrealists as well as first editions of books by French modernist poets and novelists.

The Lake collection is also rich in manuscripts, musical scores, and art by Paul Eluard, Antoine de Saint-Exupéry, Marcel Proust, Henri de Toulouse-Lautrec (nearly four hundred letters written by the young artist and members of his family), Samuel Beckett, and Claude Debussy. Like Harry Ransom, Lake was particularly fascinated by depiction of the creative process at work in manuscripts. Although he worked closely with the French book trade, he was often able to purchase important manuscripts directly from artists and writers or their estates, most notably that of Henri Pierre Roché, the author of the novel *Jules et Jim,* the basis of Truffaut's classic movie. Lake befriended Roché and managed to purchase his entire archive, including his voluminous correspondence and a long series of diaries documenting every facet of Parisian cultural life—the novelist seemingly knew *tout le monde* and led a fascinatingly intricate romantic life. Lake's later collecting tended to focus on archives rather than individual highlights.

Harry Ransom and Carlton Lake were introduced in 1969; Ransom immediately recognized that the Lake collection would make the Humanities Research Center a focal point for the study of modern French literature, music, and art. He offered Lake the position of curator of French literature in perpetuity and arranged for the collector to donate and sell the materials to Texas over a period of years. Lake took up permanent residence in Austin in 1975 and in the late 1970s became acting director of the Center. The Lake collection first came to the attention of many through the exhibi-

tion catalog *Baudelaire to Beckett: A Century of French Art & Literature* (1976). Until his retirement in 2003, Carlton Lake played an active role in the acquisition of additional French collections, such as musical scores by Maurice Ravel and Paul Dukas, and the library of Edgard and Louise Varèse. Not only did the acquisition of the Lake collection turn Austin into a Mecca for the study of modern French culture, as Ransom had predicted, but it also made it possible for scholars to examine the full extent of cross-pollination between Anglo-American and French modernism. Carleton Lake died in Austin on May 5, 2006.

Carlton Lake with the first edition of Alfred Jarry's *Léda,* 1981. The original manuscript of this one-act *opérette-bouffe* is in the Lake collection, but the book was not published until 1981. Unidentified photographer.

Jean Cocteau's ink wash and pastel illustration "Barbette?" from the Carlton Lake collection, 1923. Barbette was a cross-dressing trapeze artist from Central Texas who made a name for himself in Paris. Copyright Cocteau estate.

Although Harry Ransom had envisioned the Center as the "Bibliothèque Nationale" for the state of Texas, its reach was far more than regional; between 1963 and 1972, 82 percent of manuscript users were from outside the University and nearly 20 percent were from abroad. These percentages remained much the same in later decades. Researchers visited the fifth-floor reading room to view rare books and manuscripts, the sixth floor for photographs, and the seventh floor for theater arts and later film materials. On the fifth floor, the Research Librarian, Ellen Dunlap (who was succeeded by Cathy Henderson), assisted manuscript patrons on and off site and submitted requests for use of materials to a faculty committee for approval (this formality was discontinued in the late 1980s). In the early days of the Center, a few choice manuscripts had been "reserved" for publication by particular scholars, but this practice did not endure. The Ransom Center strongly encouraged researchers to publish manuscript material in its *Library Chronicle,* and many did so until the journal ceased publication in 1997. The Center's holdings provided the raw materials for hundreds of scholarly papers, theses, and dissertations. Bibliographies of publications based on the collections indicate how heavily many major editorial and biographical projects—on D. H. Lawrence and Bernard Shaw, for example—depended on the resources of the Ransom Center.

The Center was also becoming increasingly well known internationally for its exhibitions. In the 1970s, three shows in the Leeds Gallery of the Academic Center highlighted major acquisitions and were accompanied by handsomely produced catalogs. The first was *One Hundred Modern Books* (1971), based on Cyril Connolly's earlier book on the monuments of twentieth-century literature. Connolly, a noted British literary critic, commented in his introduction that "only the University of Texas has had the will and the means and the erudition to raise this memorial to the writers of our time."[5] First editions of key modern works, such as William Butler Yeats's *Responsibilities* or Aldous Huxley's *Brave New World,* accompanied letters, manuscripts, and other items illustrating the background and evolution of the literary text. The exhibition *Baudelaire to Beckett: A Century of French Art and Literature* (1976) and its detailed catalog revealed for the first time the richness of the Carlton Lake collection of French books, manuscripts, and art. It featured more than five hundred items, including Marcel Proust's heavily corrected proof for *A l'ombre des jeunes filles en fleur,* Antoine de Saint-Exupéry's original drawings for his fable *The Little Prince,* and Maurice Ravel's manuscript score for the ballet *Daphnis and Chloe.* The following year, *Shaw: An Exhibit* was curated by Bernard Shaw's biographer Dan Laurence. Laurence claimed—and was likely correct—that the nearly eight hundred items on display in the Leeds Gallery represented "the largest single-author display ever mounted" at that time.[6] Even

so, the exhibited items constituted only a portion of the thousands of Shavian books, pamphlets, manuscripts, film scripts, photographs, and artworks at the Center.

STRENGTHENING THE COLLECTIONS

Acquisitions in the 1970s were slowed considerably by the University's drastic cuts in the budget and the ongoing payments required for the Carlton Lake collection. The Center did, however, acquire a large collection of books printed by Giambattista Bodoni, the Italian typographical genius of the late eighteenth and early nineteenth centuries. Books from the library of poets W. H. Auden and Chester Kallmann were also added. Prominent manuscript accessions included substantial additions of Graham Greene manuscripts, the Edgar Lee Masters papers, the Carson McCullers archive, a large collection of Powys family manuscripts, and the David Higham Literary Agency archive (the bulky archives of literary agents are a Ransom Center specialty and document

Letter from Austrian archduke Ferdinand Maximilian (later Maximilian, emperor of Mexico) to his wife, Carlota, June 8, 1859

Warren Roberts at Evelyn Waugh's desk, ca. 1975. Unidentified photographer.

Helmut Gernsheim surrounded by items from his remarkable history of photography collection, 1978. Photograph by Ed Malcik.

the submerged and often complicated business aspects of literary life). The acquisition of four hundred letters exchanged by Maximilian, emperor of Mexico, and his wife, Carlota—purchased from the Belgian royal family—attracted the attention of the *New York Times*. Emphasizing Ransom's past successes and his competitive nature, reporter Martin Waldron noted: "How Dr. Ransom got the letters, widely coveted in Europe as well as North America, is not exactly clear. Dr. Ransom is guarded about revealing his methods of knowing when and where rare books and papers will become available."[7]

As in the previous decade, Ransom and Roberts relied on Anthony Rota of Bertram Rota Ltd. and Lew David Feldman for many of their

acquisitions. In the 1970s, however, the Center could no longer afford to buy entire catalogs of manuscripts, books, and art from Feldman. (Feldman died in 1976, only a few months after Ransom.) While the Center's collections were mainly expanded through purchases, one notable gift in this period was the Lundell Botanical Library, donated by Dr. and Mrs. C. L. Lundell and given a home in a replica of the couple's library on the sixth floor of the Ransom Center. At the core of the Lundell library's antiquarian holdings is a magnificent collection of historical works that include the *Hortus eystettensis* (1613) of Basilius Basler, one of the monuments of botanical engraving; first editions of Linnaeus and other early botanists; and illustrated botanical works and early herbals.

The extraordinary early photographic holdings of the Gernsheim History of Photography collection were featured in two major traveling exhibitions: *Victoria's World* (1977) and *The Formative Decades: Photography in Great Britain, 1840–1920* (1985); the latter was accompanied by a large illustrated catalog. The holdings in the Gernsheim collection were supplemented by additions of large archives from Texas photographers E. O. Goldbeck and W. D. Smithers, acquired in the late 1960s and early 1970s. The Goldbeck firm, headquartered in San Antonio, was well known throughout the state for its panoramic photographs of school and military groups. Panoramas taken by the Goldbecks, such as their striking photographs of Galveston's "Bathing Beauties" in the 1920s, East Texas oil derricks, and an aerial view of a World War II Army Air Force unit arranged in the shape of a star, became some of the most popular and frequently duplicated items from the collection. Under the curatorship of Roy Flukinger, the photographic holdings began to expand into the modern and contemporary era in the 1970s and 1980s with the acquisition of portfolios by Ansel Adams, Edward Weston, Larry Clark, and Danny Lyon.

Without question, the major acquisition of the decade was Texas's copy of the Gutenberg Bible (ca. 1455), which arrived at the Center in the summer of 1978. The University of Texas became the only university between the coasts to own a complete copy—one of only forty-eight surviving complete or nearly complete copies in the world—of the first book printed with movable type. Harry Ransom had long had an interest in acquiring Carl H. Pforzheimer's celebrated library of English literature, including the collector's copy of the Gutenberg Bible, but the plan never came to fruition before he left the chancellorship. Because the Center had already acquired, as part of the Gernsheim collection, the first photograph taken from nature (ca. 1826), the purchase of the first modern book made even more sense. In 1977 and 1978, a unique combination of circumstances brought no fewer than three copies of the Gutenberg Bible to market: the Shuckburgh copy, the General

The Gutenberg Bible, open to folios 83v and 84r (the beginning of the Book of Deuteronomy). The date "1589" is scratched into the gilt of the large illuminated initial.

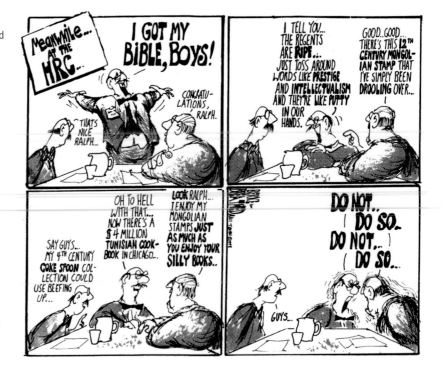

Cartoon by Berke Breathed in the *Daily Texan* poking fun at the purchase of the Gutenberg Bible, June 1978. Breathed went on to write the popular "Bloom County" comic strip.

COLLECTING THE IMAGINATION

Theological Seminary copy, and the copy owned by the Carl and Lilly Pforzheimer Foundation. Professor William B. Todd, the Center's bibliographer, led a campaign to convince the University of Texas regents to purchase one of the copies in memory of Harry Ransom and as the symbolic four-millionth volume to be added to the University's libraries (as it happened, a copy in original boards of Noah Webster's *American Dictionary of the English Language* (1828) received that honor instead). Todd and his wife, Ann Bowden, herself a trained bibliographer, investigated all three copies and concluded that the Pforzheimer Bible was the most satisfactory regarding condition, research potential, and aesthetic factors. On June 9, 1978, the Board of Regents approved the purchase of this copy for $2.4 million, with the regents appropriating $1 million and the Chancellor's Council, chaired by Ralph Spence, supplying $1.4 million in private funds.

In June, the Gutenberg Bible, accompanied by University representatives, was discreetly shipped to Austin by air, kept for examination in a guarded room in the University police station, and finally came to rest in a large marble display case with a bulletproof window in the first-floor gallery of the Center's building. The Bible rapidly became a focal point for University and state pride. Packed in a special traveling exhibition case and accompanied by armed guards, it toured the state during the University's centennial in 1983 and was seen by tens of thousands of schoolchildren and other Texans.

The Gutenberg Bible in its original case in the Huntington Art Gallery on the first floor of the Center, ca. 1980. Unidentified photographer.

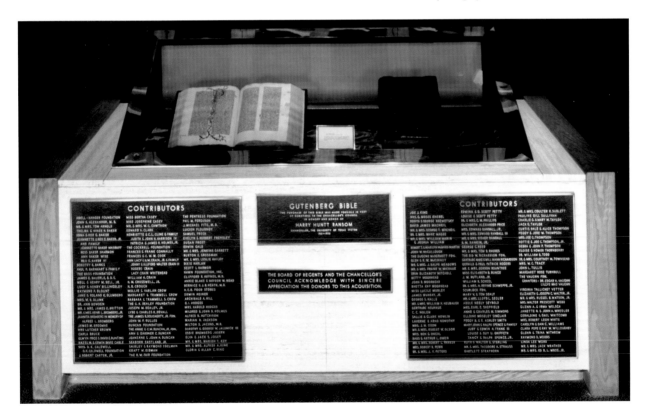

Although the internal functions of the Ransom Center continued without interruption, the institution was shaken by a series of management crises in the late 1970s. In the spring of 1978, Warren Roberts, Director since 1961, resigned following the release of an auditor's report critical of his handling of the sale of his collection of D. H. Lawrence books to the Center (Roberts maintained that the transaction had been approved in advance by the University's administration). Warren Roberts had been Ransom's "right-hand man" and since the Center's inception had had the difficult task of executing Ransom's vision for the library, which was not always fully articulated, while remaining in his shadow. Roberts had spearheaded many of the Center's most important acquisitions, including the archives of D. H. Lawrence, John Steinbeck, and Evelyn Waugh, and the Gernsheim History of Photography collection. He had also been responsible for administratively unifying the Center's older special collections with the newer ones in the Academic Center. In retirement, Warren Roberts continued to revise his bibliography of D. H. Lawrence, the third edition of which was published posthumously. He died in Austin in 1998.

Roberts's departure was soon followed by the resignations of Assistant Director David Farmer and Librarian William Holman. During this difficult transitional period, John Payne, the Associate Director, served briefly as interim director and was succeeded by Carlton Lake, the astute bookman and Curator of French Literature, who served from the fall of 1978 until the summer of 1980. Lake, whose principal interest was in collection development, made several major acquisitions during his brief tenure, including the papers of the American poet Anne Sexton and the personal libraries of James Joyce and Ezra Pound. The Sexton papers were soon put to use by her biographer, Diane Middlebrook, and became one of the most frequently consulted archives, attracting both scholars and undergraduates fascinated with the poet's illnesses, close friendships, and complicated family life, as well as the works that grew directly out of her experience. The Joyce library, which was formed by the writer when he lived in Trieste and later belonged to his brother Stanislaus, arrived in Austin in the spring of 1980 and provided insight into Joyce's reading habits, as well as sources for *Ulysses* and other works.

CONSERVING THE COLLECTIONS

The often tumultuous decade of the 1970s concluded with the hiring of Decherd Turner as the Center's new director, effective June 1, 1980.

ALL MY PRETTY ONES

Father, this year's jinx rides us apart
where you followed our mother to her cold slumber;
a second shock boiling its stone to your heart
leaving me here to shuffle and disencumber
you from the residence you could not afford:
a gold key and your half of a woolen mill,
twenty pairs of shoes, an English Ford,
the love and legal verbage of another will,
boxes of pictures of people I do not know.
I touch their cardboard faces. They must go.

The eyes, as thick as boards in this album album
are strangers; except here, a small boy
waits in a ruffled dress for someone to come.
Is it this solider, holding his bugle like a toy,
or does he love the velvet lady with a smile?
Little boy, who is this stout hairy bore
who presses his lips? Father, years meanwhile
have made it unimportant who you were looking for.
I'll never know what their faces are all about.
I lock the wooden book and throw them out.

Here is a five year diary, three years kept
in my mother's writing with all she doesn't say
of your alcoholic tendency. You overslept,
she writes. My God, father, each Christmas Day
will I drink down with your blood, your glass
of wine, ~~a diary of ninetten fourty five~~ my did
~~goes to my shelf, to wait like precioud glass~~
~~to shatter on the hour when I am no longer alive.~~
~~Father, it is necessary for your daughters outlive you.~~
~~To become less obedient and need to forgive you.~~

of wine? A diary of the hurly burly years
goes to my shelf, to wait for my age to pass.
Only in this hoarded span will love perseveer.
Whether you are pretty or not, I outlive you,
love you for loving and speak to forgive you.
bend down my strange face to yours. And forgive you.

Worksheet for Anne Sexton's "All My Pretty Ones," ca. 1961. Copyright Sexton estate.

Decherd Turner with a volume from the Giorgio Uzielli collection of books produced by the Venetian printer Aldus Manutius and his successors, 1984. Unidentified photographer.

Turner, an ordained minister who jokingly called himself "Marryin' Sam" and enjoyed presiding at the weddings of friends, had been head of the Bridwell Library of the Perkins School of Theology at Southern Methodist University in Dallas and had turned its modest special collections into a well-respected rare books library. Turner had also been successful in attracting substantial donations of materials to the Bridwell Library.

Even before his arrival in Austin, the new director had identified conservation as an especially pressing need for the Ransom Center, with its trove of modern materials, many printed or written on the highly acidic wood-pulp-based papers produced since 1870. As the Center celebrated its twenty-fifth anniversary in 1982, Turner proclaimed, "The second 25 years will repurchase through proper conservation the great materials gained in the first 25."[8] This promise was largely fulfilled during the institution's second quarter century, and the Center soon became, and remains, a pioneer in the conservation of library materials.

Turner began this initiative by recruiting Don Etherington, an administrator at the Library of Congress and a master bookbinder. Etherington in turn set about attracting skilled professional staff to head three start-up laboratories devoted to book, paper, and photography preservation. In the early 1980s, such people were difficult to find because there were so few formal training programs in the field, and thus some staff members from other departments were retrained as assistant conservators. To make room for the new laboratories, the Graduate School of Library and Information Science (as it was then called) was relocated to another building, freeing up much of the fourth floor. In the open space, Turner installed state-of-the-art laboratories equipped with fume hoods, microscopes, gas chromatographs, binding equipment, and other specialized instruments.

Preservation, involving the long-term care, housing, and protection of artifacts, was the department's first consideration, and could be carried out by staff with minimal skills and expertise. It meant, among other things, rehousing hundreds of thousands of books, manuscripts, photographs, and other materials in acid-free enclosures to protect them from deteriorating. Some preservation of this type had been done in years past, but the scale of this effort was entirely new. As staff became more skilled, they were able to treat a full spectrum of artifacts and problems. Objects were fully documented with photographs before being treated, and repairs to bindings, paper, and photographs were all designed to be reversible, in keeping with the best contemporary practices. Fortunately, the Center's sturdy building and its cooling system—other important parts of the preservation equation—had been designed to keep the extremes of the Texas climate at bay, and the controlled temperature and humidity conditions were better than those in

GETTING THE TREATMENT

The choice of a conservation treatment for damaged or deteriorating cultural artifacts is the result of a dialogue between a collection curator and a conservator. Among the factors that contribute to the decision are the significance of the item, its potential use by scholars, its condition, and the amount of time required to carry out the repair. Rehousing (creating an archivally sound package for the protection of the item) or minor mending will suffice in many instances. Some items, however, are of sufficient value to warrant full conservation treatments. For example, the publisher's pasteup of the first American edition of *The Winding Stair* (1927) by William Butler Yeats contains considerable information about in-press changes to the text on 128 layered inserts, most of them cut from galley proofs.

Unfortunately, the inserts, all of which could be interesting to scholars, were adhered to forty-four pages with aging, discolored rubber cement. The adhesive had stained all the inserts, and more than half were no longer attached to the pages of the book.

Once it arrived in the paper conservation lab in the early 1990s, the entire proof was photographed for documentation purposes. The inserts were carefully collated and separated from each other, and the adhesive residues were removed by Yasmin Khan, then an assistant paper conservator. Adhesive removal is a painstaking procedure involving hazardous solvents and must be carried out under a fume hood. Each piece of fragile insert paper was lined and reattached to the pages of the pasteup with ingenious hinges. In keeping with modern conservation practice, which stresses "reversibility," both the new adhesive (wheat starch paste) and the acid-free paper used for mends are stable and could be easily removed if a better treatment becomes available in the future. Now *The Winding Stair* is ready for safe, convenient consultation in the reading room, and the information it contains will continue to be available for later generations.

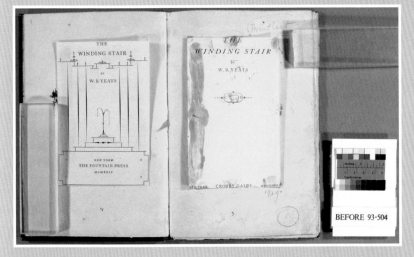

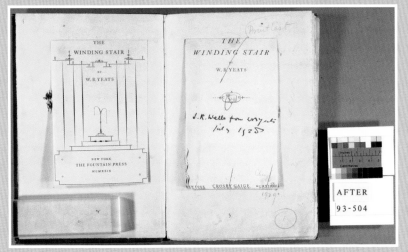

Pasteup for W. B. Yeats's *The Winding Stair*, 1927. The photographs show the proof before and after extensive conservation treatment.

Ransom Center staff with Decherd Turner (in the foreground), 1983. Unidentified photographer.

most university libraries. Concern for conservation eventually infused all aspects of the Center, from the initial inspection of materials when they arrived in the building to the ways in which they were handled by reading-room staff and researchers.

THE 1980S: A DECADE OF BOOKS

Decherd Turner was fortunate in being able to ride another wave of Texas prosperity—based on petroleum, real estate, and financial services—much like the oil boom that drove Ransom's early purchasing. At its peak, Turner drew from an acquisitions budget in the millions of dollars.

Turner was first and foremost a bookman, and acquisitions during his directorship reflected his interests. Because of his devotion to early printing, he actively pursued the donation of New York businessman Giorgio Uzielli's collection of Aldine editions—works by the early Venetian printer Aldus Manutius and his successors. Uzielli's books arrived at the Center in 1984. Particularly exciting was a unique copy of

Aldus's 1514 edition of Petrarch and the 1513 first edition of Plato's works on vellum. The Uzielli collection joined an existing group of Aldine books from the Center's Parsons library and other holdings. In all, there are more than nine hundred volumes of Aldine editions now in Austin, making the collection one of the largest in the United States.

Among the most notable single book acquisitions of the decade were the Coverdale Bible (1535), the first complete printed Bible in English (acquired in 1982 and later joined by another copy in the Pforzheimer library, giving the Center two of the twenty-three extant copies); a

Virgil's *Opera* (Venice, 1527). This volume from the Uzielli Aldine collection is bound in the Italianate style favored by the great sixteenth-century French book collector Jean Grolier and was once part of his library.

THE PORTRAIT BUSTS

Visitors to the Ransom Center are greeted by Somerset Maugham, Tom Stoppard, and W. B. Yeats, or rather, by their busts, displayed in lobby alcoves. Upstairs in the reading and viewing room, there is another contingent of portrait busts, the most visible portion of a much larger collection, many of them by notable sculptors of the age, such as Jo Davidson and Jacob Epstein. The prominent placement is appropriate because the Ransom Center is unusual, if not unique, among literary research libraries in its wide-ranging collection of literary iconography—portraits of writers and artistic works by the writers themselves.

Now known as the art collection, it began as the iconography collection, founded by Harry Ransom in the 1950s. Ransom was extremely interested in connections between literature and the visual arts, and he regarded the twentieth century as the age in which literature competed with visual media such as movies and television. Ransom also felt that works of

art by and about artists could provide essential, extraverbal insights into the nature of literary creation.

Among the writers well represented in both the art and manuscript collections are William Makepeace Thackeray, E. E. Cummings, Evelyn Waugh, D. H. Lawrence, Jean Cocteau, Denton Welch, Tennessee Williams, and Guy Davenport. Although some, like Thackeray, had aspirations to be professional artists, and others, like Williams, lacked any formal training, all found personal expression through their art.

A larger portion of the art holdings is devoted to portraiture of literary figures: a sketch by Desmond Harmsworth of James Joyce dancing a jig, an oil portrait of W. H. Auden by Sir William Coldstream, a large blue-and-white fresco by Sir Max Beerbohm featuring caricatures of Edwardian notables. In addition, the Nicholas Muray collection of Latin American art contains outstanding holdings of the Hungarian-American photographer's circle of artists and writers. Of particular importance are paintings by Frida Kahlo (including her well-known

Self-Portrait with Thorn Necklace and Hummingbird, 1940), Miguel Covarrubias, David Alfaro Siqueiros (his enormous oil *Portrait of George Gershwin in a Concert Hall,* 1932), and Rufino Tamayo. Besides providing visual riches for future exhibitions, the collection offers the raw materials for research on the connections between the visual and verbal realms of creativity.

The portrait busts have been viewed by more visitors to the Center than any other part of the art collection. Two of the most popular are a marble bust of Edith Sitwell, projecting the icy forcefulness of her personality, and Hugh Oloff de Wet's bronze of a brash and tousled Dylan Thomas, cigarette dangling from lip.

BELOW, LEFT
Portrait busts from the art collection in the Ransom Center lobby

BELOW, RIGHT
David Alfaro Siqueiros, *Portrait of George Gershwin in a Concert Hall,* oil painting, 1932. Copyright 2006 Artists Rights Society (ARS), New York/SOMAAP, Mexico City.

COLLECTING THE IMAGINATION

PORTIA

Slight point on Top.

Yoke

HAT with separate Scalp

Velvet Buttons to Cassock

SASH

Costume design by the B. J. Simmons firm, prepared for a London production of *The Merchant of Venice*, ca. 1900. The Simmons materials were acquired in the 1980s.

Bible that had belonged to the French essayist Montaigne; one of the highly sought-after copies of William Morris's Kelmscott Press *Chaucer* printed on vellum, one of the glories of fine printing; a copy of Henri Matisse's *Jazz*, probably the best-known artist's book of the twentieth century; and, though not strictly a book, the *Vollard Suite* of etchings by Picasso. Turner was especially attracted to fine printing, artists' books, and fine bindings. Well before his term, the Center had put together exceptional holdings of the classic English fine presses of the turn of the century (the Kelmscott and the Doves Press in particular); manuscripts and woodblocks of the English artist and typographer Eric Gill; the archive of the Golden Cockerel Press, which published the work of some of the finest wood engravers of the 1920s and 1930s; and nearly complete holdings for many later fine presses, such as the Grabhorn Press of San Francisco. Turner expanded the coverage of fine presses into the 1970s and 1980s and purchased many late-twentieth-century artists' books. A great admirer of James Joyce, he commissioned the best bind-

This superb floral artist's binding for Ambroise Vollard's early artist's book, acquired in the early 1980s, is by Henri Marius-Michel. The book is Longus's *Les Pastorales; ou, Daphnis et Chloé* (Paris, 1902).

ers of the day—including Philip Smith and Don Etherington—to create elaborate and sometimes exotic artists' bindings for Joyce's works, which were exhibited as a group in 1982.

The largest book collection acquired during the Turner era was Robert Lee Wolff's library of nineteenth-century British fiction. Wolff, a history professor at Harvard, began collecting inexpensive Victorian books to support his own research on the period. By the time he had finished, he owned almost 17,000 volumes of nineteenth-century fiction, many of them "triple-deckers," the three-volume novels of the period. Remarkably, the Wolff collection represents an estimated 40 percent of the total output of novels published in England in the 1800s. Though not as concerned with condition as another groundbreaking Victorian novel collector, Sir Michael Sadleir, whose collection is now at UCLA, Wolff was indefatigable in his search for the obscure works of minor novelists, including many women authors, such as Mary

Braddon and Mrs. Henry Wood. When Wolff could not obtain the first edition of a novel, he bought the manuscript instead.

During the 1980s, the purchase of literary archives—the Center's staple during the Ransom era—was de-emphasized. One exception was a group of letters, some of them remarkably erotic, from the novelist Edith Wharton to her lover Morton Fullerton. A biographer had revealed the affair several years before, but the letters added a new dimension to Wharton's portrait. Other sorts of archives, however, came to the fore. While the Carlton Lake collection already contained many autograph scores by French impressionist and early modern composers, a 1983 purchase of eighty-nine additional works added immeasurably to the collection's depth. The new arrivals included autograph scores by Debussy, Ravel ("Daphnis and Chloe"), Fauré, Dukas ("The Sorcerer's Apprentice," popularized in the Disney animated film *Fantasia*), and Roussel. In 1983, the Center came close to acquiring the entire archive of Igor Stravinsky, but negotiations with the composer's family fell apart, and the papers went to Switzerland instead.

The expansion of the acquisitions budget in the early 1980s allowed forays into previously uncharted collecting territory for the Ransom Center. Ransom had acknowledged the importance of the photographic image by purchasing the Gernsheim History of Photography

Richard Oram, Associate Director and Hobby Foundation Librarian, with a colorful publisher's binding from the Robert Lee Wolff collection of nineteenth-century British fiction, acquired in 1983

collection. Decherd Turner regarded the documentation of filmmaking, one of the legacies of the twentieth century, as a natural extension of his predecessor's original impulse to collect modern culture. "It's all a facet of the same creative enterprise," he once told a reporter.[9] In 1982, Turner arranged to purchase the entire archive of the silent film actress Gloria Swanson, famous for her portrayal of the fading star Nora Desmond in *Sunset Boulevard*. A saver by nature and highly conscious of her position in film history, Swanson kept some of her love letters from Joseph P. Kennedy (including a letter from his young son, John F. Kennedy, thanking her for a gift); correspondence with directors, actors, and producers; scripts; 20,000 photographs; and records of her cosmetics firm and other efforts to promote healthful living. The papers came to Austin accompanied by Swanson's personal archivist, Raymond Daum, who stayed at the Center for nearly a decade. The archive, like

Maurice Ravel, autograph score for the ballet *Daphnis and Chloe*, 1909–1912. This item was purchased in 1984, along with eighty-eight other music manuscripts, to be added to the Carlton Lake collection. Copyright Ravel estate.

COLLECTING THE IMAGINATION

many, also included the bizarre, most notably a three-foot-long wooden coffin filled with table sugar (anathema to Swanson, who was a health advocate), sent to the actress by one of her enemies, the Hollywood historian and scandalmonger Kenneth Anger. When the archive was processed, the sugar created a unique dilemma for conservators, who feared that it would attract insects. The solution involved encapsulating the sweet sarcophagus in clear plastic. Swanson died shortly before a planned visit to Austin in 1983, but Daum commemorated her work with a two-hundred-item exhibition in 1984 and 1985, and her daughter attended the festivities.

At a mere eight hundred boxes, the Swanson papers were dwarfed by the records of the David O. Selznick production company, weighing thirty tons. The materials came to Austin in 1981, followed soon after by the producer's own copies of his films. Selznick was famous for his personal involvement in every phase of the movie industry, and he composed tens of thousands of memoranda—all of which were carefully archived by teams of secretaries—relating to the scripts, costumes,

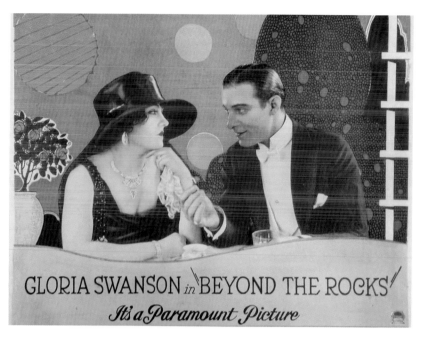

scenery, financing, and production of his films. These documents accompanied storyboards, set designs, music scores, models, and even the scissors used in the famous Salvador Dalí dream sequence of Alfred Hitchcock's *Spellbound*. The centerpieces of the Selznick archive are the production materials for *Gone With the Wind*. These materials chart the gestation and creation of the film, beginning with negotiations with the novelist Margaret Mitchell and moving through each of the eighty drafts of the screenplay to the worldwide promotion of the film. Selznick may be seen in action, grappling on paper with the choice of director and finally deciding on George Cukor. One can relive Selznick's seemingly tireless search for Scarlett O'Hara by viewing the screen tests of Paulette Goddard, Tallulah Bankhead, and a bevy of other actresses. Also included are the original storyboards, costume and set designs, the autograph score by Max Steiner, and lobby cards and posters. The most iconic items from *Gone With the Wind* are without a doubt the five dresses used for the film, including the green curtain dress made for Scarlett O'Hara by her mammy. The dresses, designed by Walter Plunkett, were briefly exhibited for the University's centennial in 1983 but proved to be too fragile for regular display. Costume conservators advised that they be wrapped in acid-free tissue and housed in specially designed containers. Recognizing that the dresses would always be in demand for display, the Center commissioned a set of replicas, accurate to the stitch, from staff and students of the College of the Incarnate Word in San Antonio, and it is these surrogates that have been exhibited to the public since 1986.

No acquisition of the Turner era attracted more attention in the library world than the Pforzheimer library of English literature. This col-

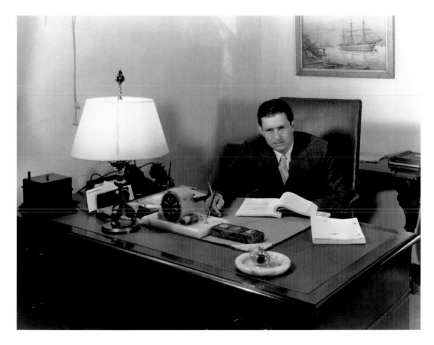

Movie mogul David O. Selznick at his desk, ca. 1930s. Unidentified photographer.

Scarlett O'Hara's dress made from the green baize curtains in her mansion, Tara, in *Gone With the Wind*, 1939. This reproduction of the original dress was made in the 1980s for display purposes.

lection of more than 1,100 first and early editions of the most important works of the greatest English authors before 1700 was assembled by New York financier Carl H. Pforzheimer between the 1920s and the 1940s. The Pforzheimer library had a high profile in the rare books world, in part because of a celebrated and frequently cited catalog of the collection compiled by eminent bibliographer and Harvard librarian William A. Jackson. Harry Ransom had frequently expressed interest in the collection, and its gem, the Pforzheimer copy of the Gutenberg Bible, had arrived at the Center in 1978. By the mid-1980s, the Pforzheimer Foundation, which housed the collection in a Manhattan office building, began to seek possible institutional purchasers. When Dechard Turner heard of the library's availability, he contacted his Dallas friend, the billionaire executive H. Ross Perot. In answer to Perot's question "What do [the books] mean?" Turner, who was generally reserved, waxed passionate, stating that he would "literally crawl to New York" to see the Pforzheimer treasures, that they were worth at least twenty million dollars, and that this opportunity was one that the University of Texas could not miss.[10] Perot trusted Turner's judgment and put up $15 million for the purchase. The Ransom Center was required to pay back the loan from its budget over a period of several years; eventually, Perot donated the same sum to the University of Texas System for the construction of a new health sciences building in San Antonio.

When the Pforzheimer acquisition, the most expensive institutional purchase of a collection of rare books to that date, was announced in January 1986, informed observers agreed that Texas had taken a quantum leap forward in early printed books. Turner himself maintained that he had supplied the "foundation" of English literary classics for the Center's great edifice of modern literature. Others grumbled that Texas was once again using its financial muscle to outmaneuver other libraries, though they overlooked the fact that the transaction drained the acquisitions budget for years to come.

In any event, the opening exhibition celebrating the acquisition of the Pforzheimer library drew the attention of scholars and the public alike, for the collection was filled with rarities. It began with the first book printed in English, Lefevre's *Recuyel of the Historyes of Troye* (ca. 1474), one of seven books printed by William Caxton. It included extremely scarce first editions of Thomas Wyatt, Edmund Spenser, and Henry Howard, the Earl of Surrey. With one stroke, the Center obtained three quarto editions of Shakespeare's plays, all published during his lifetime, as well as other quartos that appeared in the years immediately following his death and the four folio collected editions published in the seventeenth century (including the First Folio of 1623, which joined two other copies already in Austin). Other treasures included a copy of Milton's *Comus* (1637), originally from the library at Bridgewater Castle

The moſt excellent

Hiſtorie of the *Merchant of Venice*.

VVith the extreame crueltie of *Shylocke* the Iewe
towards the ſayd Merchant, in cutting a iuſt pound
of his fleſh : and the obtayning of *Portia*
by the choyſe of three
cheſts.

*As it hath beene diuers times acted by the Lord
Chamberlaine his Seruants.*

Written by William Shakeſpeare.

AT LONDON,
Printed by *I. R.* for Thomas Heyes,
and are to be ſold in Paules Church-yard, at the
ſigne of the Greene Dragon.
1 6 0 0.

where the masque was first performed. This copy is especially notable
for the inserted corrections thought to be in Milton's own hand. Several
books in the Pforzheimer library are unique, such as the mysterious *Pil
to Purge Melancholie* (1599), an Elizabethan pamphlet whose purpose
and authorship are still unknown. Far from being a mausoleum for
early English literature, the Pforzheimer library has been in constant
use since its arrival. Not surprisingly, scholars have used the books as
the bases for editions of Edmund Spenser, Ben Jonson, and other writ-
ers. These monuments of English literature have also been exhibited to

VARIATIONS ON A THEME

Many years ago, a scholar warned about the "duplicity of duplicates"— in other words, that apparently similar books can conceal differences of importance to textual scholars and historians of the book. Although it

T. E. Lawrence's well-used copy of James Joyce's *Ulysses*

is not in the best interest of large research libraries to keep duplicates indiscriminately, duplication often serves a function. Surely no one would think of the Ransom Center's three copies of Shakespeare's First Folio (1623)—the first collected publication of the plays and one of the most sought-after books ever published—as being expendable. The copies are from the libraries of Miriam Lutcher Stark, Edward Alexander Parsons, and Carl Pforzheimer, and they represent three of the most important collections associated with the Ransom Center. Further, each has a unique, fascinating story of ownership and use, reflected in the different bindings, bookplates, and repairs to the text.

The Center is justly renowned among special collections libraries for owning no fewer than thirty-four of the one thousand copies of the first edition of James Joyce's *Ulysses* (1922), the most important novel of the century. Many of these copies are not really duplicates at all because the book was published in three different formats, not including

the prepublication "press copies." A number of copies show signs of ownership, revealing who read the novel, who didn't (some copies never had the pages cut!), and what they thought of it (through their marginal annotations). The copy belonging to T. E. Lawrence—alias "Lawrence of Arabia"—shows signs of heavy use and is infused with a smoky smell, not, as it turns out, from Lawrence's pipe tobacco, but rather from the smoke and oil in aircraft repair stations, where the novel was read by the book-hungry servicemen who devoured it on their breaks.

The Center is actively involved in collecting first editions of contemporary authors, especially those whose manuscripts are in the collections. For the textual scholars and bibliographers of the future, the Center attempts to collect both British and American trade editions, prepublication proofs, and any special editions, such as limited, illustrated, or fine press versions of the same title. These variations on a theme provide essential information about the history of an author's text.

countless undergraduate and graduate classes, giving students a sense of how the works in their textbooks looked in their earliest published incarnations.

The Pforzheimer purchase was Decherd Turner's last major accomplishment, for it left little money in the budget for acquisitions. Soon after its arrival, Texas journalists began to run articles focusing on burgeoning administrative problems at the Ransom Center, raising questions about certain acquisitions, the lack of cataloging for important and expensive books, and declining staff morale. In truth, Turner had little interest in budgeting and management issues, and day-to-day affairs were usually handled by other staff. The University's administration stepped in to investigate internal problems in 1987. Later that year, Turner submitted his resignation with these parting words: "Eight years of being director of the HRC is sufficient penance for any sinner."[11] He continued to live in Austin and died there in 2002.

The explosive expansion of the 1960s and early 1970s gave way to a more inward-looking period, in which the Center confronted, and for the most part successfully addressed, the fundamental curatorial issues of caring for, cataloging, conserving, and servicing the vast collections acquired in the previous decades. New collecting areas in film history and popular culture were developed at the same time that the Gutenberg Bible, the sine qua non of great research libraries, was set in place.

In 1983, the official name of the Humanities Research Center was changed to the Harry Ransom Humanities Research Center. An adolescent institution in comparison with its peers, the Center was still in the process of seeking not only its name but also its identity. Paradoxically, it had achieved a high degree of recognition nationally and internationally—although the attention it received abroad was not always positive—but was still "a cultural treasure probably better known in London and Paris than in Dallas and Houston."[12]

1. K. Pardue Newton, "Gold at End Should Knock You Out!" *North San Antonio Times,* June 5, 1975, 7.

2. Lyons, "Last of the Big-Time Spenders."

3. Basbanes, *A Gentle Madness,* 329.

4. Hazel Ransom, *Chronicles of Opinion,* 202.

5. Connolly, "Introduction to the Exhibit," 4.

6. Laurence, Foreword to *Shaw: An Exhibit,* n.p.

7. Martin Waldron, "Books Rival Athletics at the U. of Texas," *New York Times,* January 2, 1973.

8. Turner, "First 25 Years," 26.

9. Kerry Gunnels, "UT Center Accustomed to Massive Requests," *Austin American-Statesman,* April 9, 1982.

10. David Maraniss, "University of Texas Given Major Rare-Book Library," *Washington Post,* January 22, 1986, A3.

11. Monty Jones, "HRC Director Recalls 8 Years of Fighting to Build Collection," *Austin American-Statesman* (unknown date).

12. Lyons, "Last of the Big-Time Spenders."

THE EXPANDING MISSION

THE HARRY RANSOM
HUMANITIES RESEARCH
CENTER, 1988–PRESENT

PART 4

Megan Barnard

A NEW BEGINNING

In the spring of 1988, Thomas F. Staley, then provost and professor of modern literature at the University of Tulsa, accepted the directorship of the Ransom Center. He arrived on campus in August and found a Center that seemed to embrace both sides of Texas mythos: its collections were remarkable, but the institution itself was somewhat dimmed by controversy. The Ransom Center was seen by the University's administration as an institution that needed to change. It needed a clear course, a more defined mission, and better integration into the University. It needed strong leadership and good management.

Staley got to work immediately. Collaborating with the staff, he developed a strategic plan, established departmental divisions, and strengthened the administration. From Tulsa, he brought with him history professor Michael Whalon, a seasoned administrator who was widely experienced in the field of libraries and archives. Whalon was installed as the Center's associate director and made critical contributions to the reorganization efforts. Following his untimely death, he was succeeded by Sally Leach, whose long tenure at the Center had earned her a great understanding of the institution and the respect of staff. Recognizing the talents of Mary Beth Bigger, the head of the book cataloging department, Staley appointed her to be assistant director. Staley and the staff devised a strong, concise mission statement to focus the institution's priorities. He reviewed the Center's finances and began to craft a development plan to secure much-needed funds. No one on the staff had ever been involved with fund-raising and development, with marketing or public affairs. The road ahead was long and not without bumps, but the strategic plan defined a clear, albeit ambitious, vision for the institution.

With these changes taking effect, Staley began to focus on the Center's collections. He was ideally suited for his task to build the Center's holdings, bringing academic credentials and a collector's intuition with him to Texas. Author of a dozen books on James Joyce and modern literature, he was acutely familiar with the modernist writers featured most prominently at the Center. Staley was also an astute collector who, as provost, had built the modern literature holdings at the University of Tulsa into a well-respected collection. His fiery enthusiasm, good instincts, and understanding of the inner workings of the world of rare books and manuscripts enabled him to enhance the collections with thoughtful acquisitions, not merely amassing new material, but linking the collections together by focusing on the connections writers, artists, and individual works had to one another.

A few months into his directorship, Staley achieved his first coup for the Ransom Center with the acquisition of the Stuart Gilbert archive, a rich collection of materials related to James Joyce. Carlton Lake, the Center's curator of French literature, was instrumental in helping Staley arrange this acquisition. Gilbert, a renowned translator of Malraux, Camus, Sartre, and Cocteau, was Joyce's friend and literary collaborator. He worked closely with Joyce on the French translation of *Ulysses* and on two other editions of the work, and he assisted Joyce with *Finnegans Wake*. His widow, Moune Gilbert, kept the archive in her apartment in Paris, where it had been untouched since her husband's death twenty years earlier. It was a large collection, though somewhat of a mystery because Mrs. Gilbert refused to let anyone see the full contents. As a Joyce scholar, Staley knew the enormous value of an untapped collection of Joyce materials. The Ransom Center, however, had few funds in

its budget at that time for acquisitions. Undeterred, Staley approached the University's top administrators to request support. Intent on reaffirming the Center's importance, they funded the acquisition, and the material was brought to its new home in Texas.

The collection proved to be rich indeed. It was filled with Gilbert's notes, correspondence, and drafts of his critical works and translations. Of special note was Gilbert's diary, in which he recorded his day-to-day interactions with Joyce, providing a privileged and personal portrait of the writer. The archive included letters and postcards written by Joyce to Gilbert, manuscripts of poems Joyce had written, and photographs of the Joyces. Unbeknownst to Staley when he purchased the collection, it also contained a typescript of the opening to *Finnegans Wake,* marked in Joyce's own hand with corrections. Staley quickly realized that this typescript was the missing link in the chain of previously discovered drafts that chart the evolution of the text. This one item was more valuable than the price the University paid for the entire Gilbert collection. The acquisition made headlines in the *New York Times,* bringing national attention to the Ransom Center.

James Joyce, Moune Gilbert, Lucia Joyce, and Stuart Gilbert in Strasbourg, 1928. Unidentified photographer.

The acquisition naturally aroused interest among scholars, and Staley used this opportunity to reemphasize the Center's academic focus. He featured selections from Gilbert's diary in the inaugural issue of *Joyce Studies Annual,* a journal he founded and published under the auspices of the Ransom Center for fourteen years. This journal quickly became one of the primary vehicles for publication of Joyce scholarship. The full text of Gilbert's diary was published in one of the first volumes of the Ransom Center's Imprint Series—which prints previously unpublished materials from the collections—bringing attention to the series and other Ransom Center publications.

The Gilbert acquisition provided a great impetus for the Center. It reminded the University community of the Ransom Center's strengths and its potential. Staley recognized that to sustain this momentum he would need greater financial resources to build the collections and fund ambitious programs to make them accessible. By 1990, sources of funding had become unreliable and inadequate. The Ransom legacy of relying on the Available University Fund for support was a fading option of the past, and the increasingly quixotic nature of state funding hindered planning. State support of the University was declining by 5 or 10 percent biennially.

To revive the Center's budget and create some financial stability and independence, Staley initiated a much-needed development program. Central to this plan was the formation of an advisory council. Unlike academic departments within the University, the Ransom Center had no alumni to call upon for immediate support when opportunities for acquisitions arose. The Center did, however, have several devoted supporters, and many of them joined the advisory council when it was formed in 1990. Staley enlisted Henrietta Jacobsen to serve as the first chair of this group. Jacobsen had been Harry Ransom's close ally and assistant, and she led the Center through the uncharted waters of council formation. She was instrumental in establishing the council as a group of staunch supporters and a reliable source of practical advice. The council has since become a crucial link between the Center and a broad base of potential donors. Members have resided all over the United States and Europe, building connections for the Center beyond Austin and Texas, and infusing the Center with a broader national and international perspective.

The council has had a distinguished roster of members, among them Texas Pulitzer Prize–winning author Larry McMurtry and writer, artist, and publisher Fleur Cowles. Cowles was the creative force behind the legendary *Flair* magazine, which ran for only thirteen issues in 1950 but retains a place of influence in the history of American magazines. *Flair* paired the works of writers, artists, and critics with marvels in design—die-cut overlays, foldouts, and other technically innovative flour-

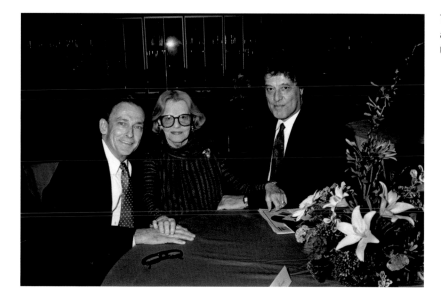

Tom Staley, Fleur Cowles, and Tom Stoppard at the Fleur Cowles Flair Symposium, 1996. Unidentified photographer.

ishes—to bring together what it termed "the new, the controversial, the innovative, and the creative."

In 1992, Cowles came to Austin to visit her friend Lady Bird Johnson. At the suggestion of law professor Philip Bobbitt, the former first lady's nephew, Staley invited Cowles to the Ransom Center for a tour of the facilities. She was immediately drawn to the collections and to the Center's aim to bring together the literary and artistic achievements of the twentieth century, a goal she shared in her own work. Thus began a philanthropic relationship that has sustained for more than a decade. Cowles joined the advisory council, and shortly after her visit, she made a million-dollar bequest to the Center, which the University partially matched to establish the Fleur Cowles Endowment. The endowment supports fellowships, internships, acquisitions, a biennial academic symposium, and the Fleur Cowles Room in the administrative wing of the Center's building. The room was designed to replicate Cowles's study in her London home, demonstrating her characteristic flair with yellow walls, leopard-print furniture, and a collection of her original artwork.

Fleur Cowles gave the Ransom Center its first large monetary gift, supplemented in the years since with annual donations. Her support provided immediate relief for the Center's tight budget and a steady stream of funds for an expanded academic agenda. The endowment is used to support a graduate internship program that has introduced more than fifty students from various academic backgrounds to the field of rare books and manuscripts. It also led to the establishment of one of the Center's principal academic programs, the Fleur Cowles Flair Symposium, initiated in 1994 and held biennially at the Ransom Center. Past symposia have explored an array of themes, from the future of the library to the state of the publishing industry, from the contemporary

British theater to the history of modernism. Cowles was the guest of honor at many of these events, which have become known for thoughtful lectures, charged debate, and a distinguished cast of speakers.

A DECADE OF COLLECTING

With the advisory council in place and a fledgling development program gaining strength, Staley began to look seriously at the Center's collecting practices. He established a curatorial council, which met periodically to discuss acquisitions, exhibitions, and issues related to the collections. Two curators in particular, John Kirkpatrick and Cathy Henderson, knew the Center's British and American literature holdings thoroughly, and with Carlton Lake they became Staley's invaluable consultants on collection development. Staley and the curatorial staff quickly recognized a need to develop a focused plan for acquisitions. In the economic realities of the present, the Ransom Center could no longer simply purchase materials by offering the highest price, as Harry Ransom once did, or automatically make the highest bids at auction. The Center would lose in the early 1990s the Nadine Gordimer archive to the Lilly Library at Indiana University, a collection of Graham Greene letters to Boston College, and the Kenneth Tynan archive to the British Library. Without a plan, the Ransom Center, which had such strong collections of the first half of the twentieth century's literature, would have only that—the first half.

The Center thus embarked on a plan to balance its holdings in the second half of the century in British, American, Canadian, Irish, and anglophone African literature. With the help of faculty, book dealers, and writers, the curatorial staff identified a list of literary heavyweights who had published their first work after 1950. For most of these writers, the Center collects all first editions of their works. For a select group, all published works—including translations and special editions—and manuscripts are collected. The list is not based on aesthetic judgment alone. Other factors include the availability of manuscripts and an author's connection with other writers represented in the collections. Writers on the list extend throughout the second half of the century from William Golding to Toni Morrison, from John Updike to J. M. Coetzee, from Walker Percy to Salman Rushdie. The list includes young writers such as Jonathan Franzen, Zadie Smith, and David Foster Wallace. Staley and the Center's librarian, Richard Oram, work with book dealers to ensure that new works by these writers are purchased for the collections. The dealers also buy retrospectively when needed, filling in missing items. This collecting program has built, in an affordable way,

OPPOSITE PAGE, TOP LEFT
"Programme" of *Arcadia* from the premiere production at the National Theatre

OPPOSITE PAGE, BOTTOM LEFT
Tom Stoppard with the cast of *Arcadia* after the Brussels production in 1993. Photograph by Daniel Locus. Copyright Locus.

OPPOSITE PAGE, TOP RIGHT
Hand-corrected typescript of Tom Stoppard's *Arcadia*. Copyright Tom Stoppard.

OPPOSITE PAGE, BOTTOM RIGHT
Stoppard incorporated ideas related to chaos theory and thermodynamics into the intricately structured plot of the play. While writing, Stoppard often consulted with his son, a physics graduate student at Oxford University, and with his son's colleagues. This page from a faxed explanation of the second law of thermodynamics was written by Oxford scientist Robert May. Courtesy of Robert May.

THE ANATOMY OF AN ARCHIVE

Every archive in the Ransom Center's collections is unique, yet most archives share some common elements: correspondence, a succession of manuscript and typescript drafts that show the evolution of a text, diaries, journals, business papers, page proofs, and other items related to the work of a writer or an artist. Archives also often include photographs, artwork, books, and the occasional personal effects. These materials provide invaluable informa-tion to textual and bibliographic schol-ars, historians and philosophers, and other researchers. They serve as source material for new editions of works and for critical analyses. They also provide a wealth of interesting, and often reveal-ing, materials for exhibitions.

The archive of British playwright Tom Stoppard was acquired by the Cen-ter in 1991, and Stoppard has made sev-eral subsequent additions to the collec-tion. It includes typescripts of his many plays, handwritten manuscripts, page proofs, galley proofs, theater programs, photographs and negatives, advertis-ing material, clippings of articles and reviews, correspondence, production files, and fan mail, among other items. Nearly all of Stoppard's major plays, screenplays, teleplays, and radio plays are represented in some form, along with many of his lesser-known works and some that were never produced.

The items displayed here offer an example of the variety of materials in a writer's archive. Each of these items relates to Stoppard's play *Arcadia,* which opened to acclaim at the National Theatre in London on April 13, 1993.

ON SELLING THEIR ARCHIVES

The purchase of a contemporary writer's archive involves a somewhat speculative judgment by a research institution on whether the writer will be studied in the future. As the institutional buyer grapples with this issue and considers the substantial investment it will make to preserve the collection, one might suspect that the writer, pleased with the prospect of financial remuneration, has only a passing interest in where the collection will eventually reside. According to Tom Staley, "Just the opposite is true; most writers, however modest, are deeply interested in this aspect of the gift or purchase and are extremely attentive to the fate of their papers once they enter the walls of a research library."[1]

British playwright Arnold Wesker and American novelist Diane Johnson have both written about their experiences selling their archives to Texas and their reasons for doing so. Wesker's account reveals not only how his collection came to the Ransom Center but also how the sale of an archive can be an emotional challenge for a writer. He

writes, "The selling of archives is the writer's final reckoning—in this life at least. You sell archives when you need money and space, and the moment you offer is the moment you ask the world to judge you, tell you what it thinks you're worth."[2]

Wesker first gave serious thought to selling his collection when he was approached by the British Library. "Wonderful! My country loves and respects me after all," he writes, "and my beloved manuscripts would be round the corner." Negotiations with the British Library, however, broke down when neither party could agree on a price.

"Enter Dr. Thomas F. Staley," writes Wesker, "one of the most sensitive, erudite, sympathetic noses in the archive trade . . . 'What figure did you have in mind?' he asked. I paused for the merest second and uttered a round figure . . . To his credit Dr. Staley didn't blanche but could see that he was dealing with no slouch here. 'That's more than we paid for John Osborne's or Tom Stoppard's papers,' he said . . . [I] replied: 'Oh, but they were not diarists.'"

Wesker and Staley eventually agreed on a price. Wesker notes, "I went back to contacts in the UK who advised me to forget this country, there wasn't either the money or the interest. Texas had superb facilities—let them have it. Which I did."

He concludes, "Emotions are mixed—relief, regret, loss. I feel secure, bereft, demeaned, flattered . . . What is unarguable, however, is the honour bestowed when purchased by a prestigious university. Honour doesn't plug

up a leaking roof, and we all would prefer to be honoured in our own country, but honour is honour. And we are content."

In Diane Johnson's account, she explains why she sent her papers to the Ransom Center rather than to a library in California. She writes, "Of course money had something to do with it. But not everything."[3]

More important to Johnson was the commitment the Center was willing to make to her collection. "Texas preserves the complete papers of people," she writes. "UCLA asked me once for the manuscripts of novels set in Los Angeles for their collection of California novels. UC Berkeley had a similar request, but this gives the poor author no help dealing with the rest of the papers that accumulate."

"A more central reason for sending my papers to Texas," she writes, "was that I had worked with the Harry Ransom Center when I was writing a biography of Dashiell Hammett, so I had a high regard for it. Hammett's papers and those of Lillian Hellman were there, and the librarians had been helpful and thorough."

Johnson was excited about being included among the collections. She notes, "I loved the idea that they also had papers of John Ruskin and Hemingway and thousands of others—one of the greatest collections in the world."

"Most important," she concludes, "I felt that my Hammett materials, say, and my manuscripts would be in a place where people cared about such things, nothing to do with me especially, but in a spirit of preserving in general."

Arnold Wesker directing *The Wedding Feast*, 1996. Unidentified photographer.

the Center's holdings of writers whose reputations would grow with the years. Nearly 25,000 volumes have been added since its inception.

Like his predecessors, Staley formed close relationships with a select group of book dealers and agents. He continued the Center's long association with the firm of Bertram Rota, who—along with Rick Gekoski of London—has helped the Center acquire the works of major British writers. In the United States, Staley has looked to Glenn Horowitz, Howard Woolmer, Ralph Sipper, Peter Howard, and Gotham Book Mart's Andreas Brown to keep him abreast of available collections. These agents and others have been especially valuable in bringing together the Ransom Center and writers who are ready to place their archives in an institution.

Writers' archives were the primary collecting focus in the 1990s, when more than one hundred were acquired. Among these archives was an important cache of collections related to the postwar British theater. British theater had undergone a marked transition in 1956 with the opening of John Osborne's play, *Look Back in Anger*. This production was heralded by critic Kenneth Tynan as the first totally original play of a new generation, clearly breaking from the popular "drawing-room" comedies of the early 1950s that focused on the affluent leisure class of England. Osborne's play portrayed the domestic lives of the working class and conveyed language in its everyday, often inelegant bluntness. The play sparked a rebirth in the British theater that was highlighted by the works of playwrights Arnold Wesker and James Saunders and extended to the contributions of Tom Stoppard and David Hare. In a span of merely four years, the Ransom Center acquired the archives of these prominent playwrights. Discussing these acquisitions with the *Austin Chronicle,* Staley noted:

We had such a strong collection of the Americans. We had Arthur Miller, Tennessee Williams, Lillian Hellman, and a strong showing of Eugene O'Neill. Among the British writers, we had a strong collection of Shaw, as well as substantial material for T. S. Eliot and a smattering of material for Terrence Rattigan. But we simply did not have the later playwrights. So some years ago, we decided to acquire some . . . Our first acquisition was Tom Stoppard's archive. I felt that he was clearly one of the major figures of our time. Totally independent of the Stoppard acquisition, we began to talk to David Hare. He represented a very different kind of writer . . . [He was a] playwright of social theatre. I also had strong contacts with John Osborne . . . And we had one of the strongest Beckett collections in the world.[1]

This collecting focus extended beyond the archives of playwrights. The papers of British actor, producer, and director Frith Banbury were

also acquired, along with other collections that enabled scholars to look more widely at this era of theater, from scriptwriting and set design to acting and production. The Center focused its 1996 Flair Symposium on the British theater, bringing Stoppard, Hare, Banbury, and others to Texas. Concurrently, the Center presented the exhibition *Shouting in the Evening: British Theater 1956–1996.* In his introduction to the exhibition catalog, Staley remarked that the forty years represented in the exhibition were "a time during which playwrights, producers, actors, directors, and companies created the richest theater in the Western world . . . no theater has produced a comparable array of talent, richness, diversity, and range."[2]

During the 1990s, the Ransom Center looked to British writers in other genres as well. It acquired the archives of prose writers John Fowles, Anthony Burgess, and Booker Prize winners Penelope Lively and Penelope Fitzgerald. As in the 1960s under Ransom's lead, the Center was scooping up the collections of many of Britain's greatest writers. British libraries were generally restricted by funding sources that encouraged the collection of writers' works only after they had been deceased for years and their positions in the canon were well established. As a result, the archives of Britain's top contemporary writers were moving en masse to American institutions. This archival migration heightened a sense of nationalism about cultural materials, and once again the British press focused its frustration on the Ransom Center. British newspapers regularly ran stories about the Center's acquisitions, decrying what they described to be the "scandal" of Britain's lost literary archives. Far from viewing the situation as scandalous, however, other writers argued that preserving cultural materials was a mutual enterprise that, by necessity, must reach across the Atlantic. In defense of the Ransom Center, British professor and columnist John Sutherland wrote in *The Guardian:*

There are those who cast institutions such as the Ransom Centre as genteel brigands—looters with bulging wallets rather than AK47s. They are not. They do what we should be doing and they do it superbly well. We should either thank them from the bottom of our hearts or take on the job ourselves.[3]

Although the Ransom Center was receiving broad attention for its British acquisitions, American writers were not neglected in this period. The Center acquired the archives of Elizabeth Hardwick, Peter Matthiessen, William Humphrey, and James Salter. The collections of poets Karl Shapiro, Stanley Burnshaw, and James Tate were also added.

In the early 1990s, the archive of Nobel Laureate Isaac Bashevis Singer became available, and Staley was determined to bring it to Austin. It

was an expensive collection, and he had to look outside the University for financial support. A gifted fund-raiser who knew precisely how to appeal to the interests of donors and get people excited about a collection, he let loose his charms. As Staley tells it:

"We got nine people in Texas and one friend of mine in Oklahoma, and we formed a minion and got this collection. Nobody could believe how we ever got it out of New York, and Roger Strauss of Farrar, Strauss & Giroux [Singer's publisher] just loved it, and helped us a great deal afterwards, too."[4]

David Douglas Duncan shows Pablo Picasso how to take a photograph, 1957. Photograph by Jacqueline Roque.

The Singer collection was soon joined by the archives of Leon Uris, Bernard Malamud, and Jay Neugeboren, making the Ransom Center a key institution for the study of American Jewish writers, a collecting focus it has continued to strengthen. In 1997, it established a $1 million endowment, the Albert and Ethel Herzstein Jewish Literature and Culture Fund, which has since supported acquisitions, programs, and exhibitions that promote the study of Jewish culture.

International writers were also a focus in the 1990s, and major collections of Jorge Luis Borges (from Argentina), Amos Tutuola (from Nigeria), and Anita Desai (from India) were added. The Center enhanced its holdings in the American theater, in which it was becoming quite strong, by adding new material to its Arthur Miller and Tennessee Williams collections. It added the archives of playwrights Adrienne Kennedy, Lee Blessing, and Terrence McNally, and theatrical agents Audrey Wood and William Liebling. The Ransom Center also looked beyond literature, strengthening collections in film, art, music, and especially photography.

In the mid-1990s, Staley received a phone call from Dallas businessman Stanley Marcus, president of the Neiman Marcus department store. Marcus asked Staley if he was familiar with the work of world-renowned photojournalist David Douglas Duncan. Though it had been several years since Staley had attended an exhibit of Duncan's works, the images had so impressed him that many of them remained seared into his memory. Marcus asked Staley whether he thought Duncan's archive might find a home at the Ransom Center, and Staley resolved to make it so. He took a trip to the south of France to visit Duncan at his home and brought Duncan to the Ransom Center to see the facilities and the collections. They began to build a relationship that led to the 1996 donation of Duncan's comprehensive archive to the Center. Since then, Duncan has continued to add to the collection, which includes his dramatic images of war from World War II, Korea, and Vietnam; his contributions to *Life* magazine; materials from all of his books; and his famous photographs of close friend Pablo Picasso. His archive

David Douglas Duncan's photograph of the Turkish cavalry on the Russian frontier, 1948

comprises 800,000 original negatives, photographs, and prints, as well as manuscript materials. It has become one of the centerpieces of the Ransom Center's photography collections. Perhaps just as important as these materials, however, is the close relationship that has developed between Duncan and the Ransom Center. Duncan has become an enthusiastic supporter of the Center's photography program. He has made regular trips to Austin to work with his collection or to speak publicly, as he did in 2002 when he inaugurated the David Douglas Duncan Endowed Lecture in Photojournalism. In 2005, he made a major bequest to the Center to strengthen the photography department.

The Center highlighted the major acquisitions of the 1990s in its spring 2000 exhibition, *Islands of Order: A Decade of Collecting*. The exhibition, mounted in the Leeds Gallery of the Academic Center, was accompanied by a published catalog.

THE RANSOM CENTER IN LITERATURE

Because of its explosive growth, its reputation for scooping up the papers of English and American literary figures, and its location in the heart of Texas, a state known for outsized things, the Ransom Center has become somewhat legendary in some literary circles.

Sly references to it pop up in several novels. One thinks especially of A. S. Byatt's *Possession* (1990), whose subplot involves Mortimer P. Cropper, Trustee of the Stant Collection at Robert Dale Owen University in Harmony City, New Mexico. Cropper befriends relatives of the Victorian poet Randolph Henry Ash, hoping to get his hands on unpublished Ash letters and memorabilia buried with the author. His scheme is foiled when he is discovered rifling through the grave. The struggle of Roland Michell and Maud Bailey, two scholars who are the focus of the novel, to keep the papers in England is reminiscent of the strong opposition that developed in the 1970s to "the manuscript drain" of English literary heritage to America (especially Texas).

"A deranged university in Texas" offers the protagonist of Stephen Fry's *The Hippopotamus* (1994) money for his papers. Briefly bemused by the request, the poet responds by forging "dozens of likely-looking rough drafts of my better-known poems" in different-colored inks.

Ed Sanders's *Fame & Love in New York* (1980) features a character named Arthur J. Adamson, known as "Art Archives." A caricature of the major players in the field of literary archives, Art was "the first to bring 'case officers' into modern Archive-istics, many of them burnt-out intelligence agents, each of whom resided as a 'desk officer' responsible for a specific data-target, usually a living or recently deceased poet or novelist."

Poet Albert Goldbarth highlighted some of the unlikely items housed in the Center's collections in these lines excerpted from "Hunt," published in *Arts & Sciences: Poems* (Ontario Review Press, 1986).

On the 5th floor of the U of Texas
 Special Collections Library
is the "vertical file"—miscellaneous
junk-cum-exotica storage. What is it,
that asking for Leigh Hunt's
 catalogued compendium
should encourage an offer of being
 toured through this
mess of lesser literary curio-detritus:

John Masefield's teddybear "Bruno."
 Two
cigarette butts of John Cowper
 Powys's (June 7, 1939)
and a swatch of his hair. "Cuttings
 from Shaw's beard."
Whitman's hair (1890–92) and a gold
 pin
with a lock of hair at its heart.
 [Gertrude] Stein's
waistcoat. Carson McCullers's
 nightgown. All,
both pellings at once: re-, com-. Poe's
 glasses.

The Coleridge family hair. And Arthur
 Conan Doyle's
cuesticks and golf clubs and
 hairbrush and
socks with a note: "The socks which
 were on
my Belovéd's feet—put on by the
 nurse after
he had passed on—Which I took off
 and replaced
others with my own hands." I don't
 want to know.

I want to know. Robinson Jeffers's
 hair. Poe's hair
in a brooch "of spiral gold," you can
 see it coiled
tensely inside like a watchspring.
 Compton Mackenzie's
rubber toilet cushion and kilt. And
 "Clarence
E. Hemingway's first 3 white hairs."
 Earle [sic] Stanley Gardner's
brass knuckles and credit cards and
 his photographs
of 2 views of a skunk and his
 "Oriental bamboo sleeve gun
with blood-encrusted darts" and the
 tapes of him
learning Spanish. This is all true. And
 the hair, almost
always the hair, that most supremely
 voodooesque
of the body's various flotsam
 mnemonics we pick up
tangled and bleached on an alien
 shore and with it recall
the whole life. Hair. A bottle village.
10,000 pencils, "you know." Iron mice.

—Courtesy of Albert Goldbarth and
 Ontario Review Press

The great influx of collections in the 1990s perhaps inevitably led to a renewed focus on cataloging. Manuscript cataloging practices at this time had become unwieldy and outdated, resulting in a growing backlog of uncataloged manuscript materials. Kris Kiesling, a rising star in the field of archives and manuscripts, was hired to address this problem. She redefined manuscript cataloging practices for the Center, creating collection-based descriptions that were far more manageable and efficient. Additional archivists were hired to reduce the backlog and make the materials available for research. The book cataloging department, which for years had worked officially under the auspices of the University's General Libraries, was finally incorporated into the Ransom Center in 1996, a move that made sense logistically and boosted staff morale. In 2003 the last of the old card catalog records were converted to digital form, making it possible to search nearly the entirety of the Ransom Center's book holdings at any time from any networked computer in the world. The Center's administration also began to seek outside funding to support large cataloging projects. Major grants from the National Endowment for the Humanities funded the cataloging of the papers of the Alfred A. Knopf publishing house, one of the Center's largest collections, and the preservation and cataloging of the archive of theatrical costumier B. J. Simmons and Company. A grant from the Andrew W. Mellon Foundation supported the preservation and cataloging of four French literary collections: the Carlton Lake collection, the papers of Edouard Dujardin, the William Bradley Literary Agency files, and the papers of Romanian Princess Marthe Bibesco. These efforts to enhance the Center's cataloging practices and resources helped ensure that the valuable collections the Center was acquiring would be accessible to generations of students and scholars.

A ROOM OF ITS OWN

The robust collection development of the 1990s enhanced the Center's international stature, but it also presented new challenges. The Ransom Center lacked comfortable and accessible facilities to share its collections with the public. Since the 1972 opening of the Ransom Center's building, the Huntington Art Gallery (now named the Blanton Museum of Art) had occupied most of the first and second floors and nearly all usable storage space in the basement. The spaces occupied by the Blanton were among the most prominent in the building, leading the public to identify the Ransom Center with the Blanton's collections. With research and seminar rooms hidden on the fifth and sixth floors and an exhibition gallery on the upper floor of an entirely

Renovation of the Ransom Center's new
lobby, reading room, and gallery, 2003

The remodeled Ransom Center building, 2003. Photograph by Marsha Miller, UT Office of Public Affairs.

different building, the Ransom Center was barely visible to the public and largely under recognized. Storage space had also become scarce, complicating the Center's collecting programs. Solutions to these mounting problems seemed elusive in the early 1990s.

On September 1, 1995, however, a headline in the *Daily Texan* heralded good news: "University to Construct New Art Museum." The Blanton Museum would finally have its own facilities, and a major limitation for the Ransom Center was soon to be resolved—the Center would claim possession of its entire building, adding nearly 45,000 square feet to its territory and enabling it to establish a distinct identity in the public conscience.

Associate Director Sally Leach coordinated the reconstruction efforts—a task she embraced with fervor and energy. She was amply assisted by Ransom Center staff, most notably by James Stroud, head of conservation and building management. The final design of the building was drafted by Lake/Flato Architects of San Antonio, which in 2004 received the prestigious American Institute of Architects Firm Award for its work on the Ransom Center and other buildings. The architects crafted a design that fulfilled the Center's needs and, in spite

of the building's structural limitations, created a welcoming, attractive façade.

Construction began on August 20, 2001. Twenty months and $14.5 million later, the building was completely transformed. Stephen Kinzer wrote in a feature story of the *New York Times*, "Scholars know the Ransom Center as one of the world's pre-eminent research libraries, but until now the public has caught only fleeting glimpses into its rich chambers. That will change in April when the center opens its first galleries."[5] On April 12, 2003, the Ransom Center celebrated the completion of the building with a gala. That same month, the Center's new research wing on the second floor opened to the public. It included a new reading room, a viewing room for photography and art, and seminar classrooms, consolidating the public service and research facilities for the first time. These facilities, infused with natural light and a warm and gentle ambience, atoned for the sterility of the fifth-floor reading room that had been used for the previous thirty years.

On May 12, 2003, the Ransom Center Galleries opened to the public for the first time with the exhibition *In A New Light,* which featured many of the Center's most iconic items. The Gutenberg Bible, removed from its display during the renovation, was reinstalled in a newly designed, climate-controlled case in a prominent space in the lobby. The wooden surround for the case is adorned with an apposite passage from Ecclesiastes, displayed in an enlarged facsimile of Gutenberg's type: "Quid est quod factum est. Ipsum quod fiendum est faciendum" ("What has been is what will be, and what has been done is what will be done; there is nothing new under the sun"). The permanent display was joined in the lobby by Joseph Nicéphore Niépce's heliograph, the first photograph created from nature, also housed in a state-of-the-art protective environment. The Ransom Center finally had a room of its own in which it could share its collections with the public.

The renovation was functional, adding gallery and theater space and transforming the reading room into an attractive, comfortable work environment. The renovation was also aesthetic, bringing natural light inside and emphasizing what it is that makes the Ransom Center so remarkable: its collections. Two previously recessed corners of the building were enclosed with walls of glass etched with images from the collections—a portrait of James Joyce, Picasso's eyes as photographed by David Douglas Duncan, scenes from *Gone With the Wind,* and hundreds of other arresting images. The entrance doors were framed by the signatures of many of the writers and artists whose works reside inside—as an endorsement, of sorts, of the Center's collections and its mission.

In a front-page story in the *Los Angeles Times,* Christopher Reynolds wrote of the Center shortly after its reopening:

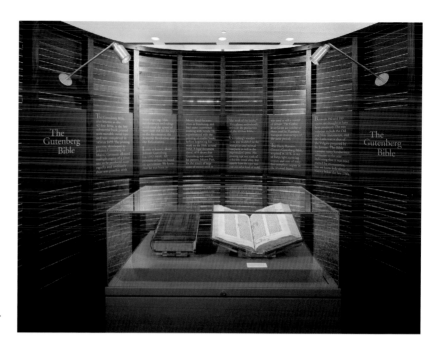

The Ransom Center's Gutenberg Bible, 2004.
Copyright Thomas McConnell Photography.

Local jazz ensemble performs in the
Center's lobby for a special "Poetry on the
Plaza" session on Beat writers, 2005. In
the background is the enclosure for the
Gutenberg Bible.

*No disrespect is intended to your local public library. But to glimpse 36
million of the most coveted pages in all of literature, and possibly Sir
Arthur Conan Doyle's underwear, serious book folk know they must come
here, to the same Hill Country that gave this nation Lyndon B. Johnson,
"The Texas Chainsaw Massacre" and its largest public university . . . For
decades scholars have rummaged here in solitude and wonder, sorting
through a collection laid out something like a bottom desk drawer eight
stories deep. But now, for the first time in its improbable 46-year history,
the center has a clean, well-lighted place to show off its massive holdings
for a wider audience. And as an increasing number of libraries nation-
wide begin to behave more like museums, this Austin building may stand
as a hint of things to come.[6]*

COLLECTING THE IMAGINATION

IN A NEW LIGHT:
THE FIRST PHOTOGRAPH

On June 13, 2002, the First Photograph, Joseph Nicéphore Niépce's "View from the Window at Le Gras," was carefully packed and loaded into an art shipping company's eighteen-wheeler for a journey to the Getty Conservation Institute in Los Angeles, California. The Ransom Center's head of photographic conservation, Barbara Brown, accompanied this cultural treasure to the Getty, where it was scientifically examined and analyzed for the first time.

Scientists at the Getty performed noninvasive tests to determine the photograph's chemical makeup. They confirmed that it was created on a pewter plate (made of tin alloyed with lead and containing traces of iron, copper, and nickel) that had been coated with a light-sensitive substance called bitumen of Judea.

Conservators at the Getty repaired the original gilt wood frame and created a new, environmentally controlled, oxygen-free case for the First Photograph. After two weeks, the photograph was returned to the Ransom Center. In 2003, it was installed in a permanent enclosure in the Center's remodeled lobby, and it was fitted into its new case in August 2004. The case allows for continuous, computer-based monitoring of the argon atmosphere around the photograph and automatically notifies conservators if internal conditions exceed safe limits. The display provides the ideal lighting conditions to view the faint, underexposed image.

Niépce created the first permanent photograph from nature in 1826 or 1827. After coating a pewter plate with a solution of bitumen of Judea in lavender oil, he placed the plate into a camera focused on a sunlit scene from the third-story window of his home

in the French village of Saint-Loup-de-Varennes. During the eight-hour exposure time, light from the scene bleached and hardened the bitumen. Niépce then developed the exposed plate in oil of lavender and mineral spirits, dissolving away some of the bitumen in the partly exposed areas and all of the coating in the unexposed shadow areas, revealing the dark gray metal beneath. The bleached and hardened bitumen in the light-exposed sections of the image remained on the pewter surface, providing the contrast that makes the image visible. Niépce called his process "heliography," derived from the Greek words *helios,* meaning "sun," and *graphein,* denoting "writing" or "drawing."

The Ransom Center acquired Niépce's photograph in 1963 as part of the Center's great historical photography collection, compiled by Helmut and Alison Gernsheim.

The First Photograph, Joseph Nicéphore Niépce's heliograph, in its permanent enclosure in the Ransom Center's lobby, 2005

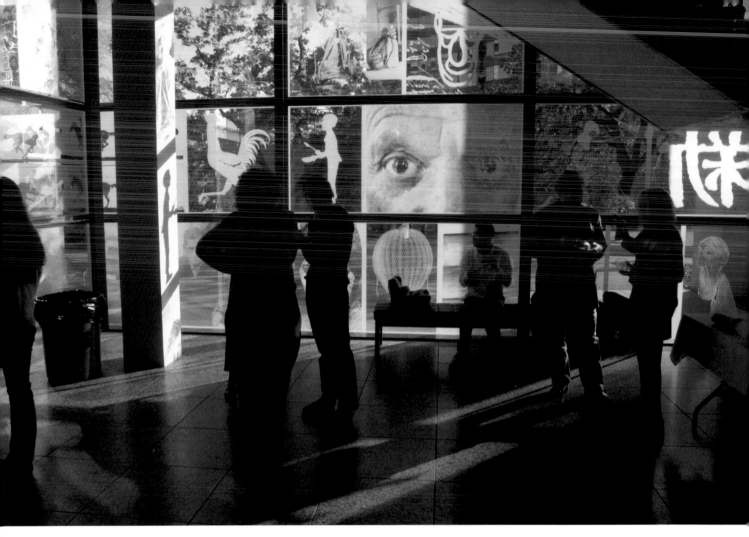

Etched windows surrounding the south
atrium, 2003

Entrance to the Ransom Center, 2004.
The windows surrounding the front doors
are etched with the names of writers and
artists whose collections are housed inside.
Copyright Thomas McConnell Photography.

COLLECTING THE IMAGINATION

Far from being a mere architectural transformation, the building reno-
vation reshaped the character and philosophy of the institution. The
Center's staff grew even more committed to sharing the collections in
new and engaging ways. To reflect this commitment, Staley redefined
the Center's mission, broadening it to include a greater focus on public
programs. The Center established a membership program to encour-
age individuals to become actively involved with the institution and its
programs. Staley also restructured the Center's administration to better
reflect its expanded mission. After the retirement of Associate Director
Sally Leach and the departure of Associate Director for Development
Sue Murphy, Mary Beth Bigger was promoted to executive associate
director and second in the administrative line. Four new associate di-
rectors were appointed: Kris Kiesling, who headed technical and digital
services; Richard Oram, the Hobby Foundation Librarian and head
of public services; James Stroud, head of conservation and building
management; and Jeff Melton, the associate director for development.
Cathy Henderson was later named associate director of exhibits and
education. New curatorial positions were also created to address the
growing needs of the Center and to provide dynamic programs, lec-
tures, conferences, and exhibitions.

Ransom Center members enjoy a special
preview of *In a New Light*, the inaugural
exhibition in the Ransom Center Galleries,
2003.

The Ransom Center, of course, had been mindful of the public for years, though its reach had not extended much beyond the academic community. It had sponsored and hosted distinguished programs and symposia, most free of charge and open to all audiences. Its liberal public services policies enabled anyone with a legitimate research need and photo identification to request and view materials in the reading room. Many of the exhibitions in the Leeds Gallery on the fourth floor of the Academic Center had been critically celebrated, though the remote location rarely attracted visitors outside the academic community. During the renovation, the Center experienced a taste of what it would be like to feature a large-scale exhibition in a proper gallery when Harry Middleton, the director of the Lyndon B. Johnson Presidential Library, agreed to host the Center's exhibition *From Gutenberg to Gone With the Wind*. The exhibition was widely attended, foreshadowing the future success of the Ransom Center's exhibitions and introducing new audiences to its collections.

In the first year after the renovation, the Ransom Center had more than 85,000 visitors, an exponential increase over previous years. Visitors viewed the exhibitions, strolling through the galleries on their own or under the guidance of a volunteer docent. Public school teachers attended summer teaching institutes during which they helped prepare curricula related to future exhibitions. These teachers and others returned with their students during the school year to tour the exhibitions. University students attended classes, academic lectures, and programs in the newly remodeled building. Students, faculty, and University staff enjoyed "Poetry on the Plaza," a public program in which local celebrities read poetry from the collections at noon on the first Wednesday of each month in the Center's tree-filled plaza.

The Center's expanded programming initiative began in earnest in support of its celebrated exhibition *Make It New: The Rise of Modernism*, the second exhibition to be featured in its new galleries. A full schedule of public lectures corresponded with the exhibition, exploring a range of topics, from modern art and conceptions of God in the modern era to modernism itself. The Center focused its 2004 Flair Symposium on this theme, bringing together scholars, librarians, publishers, collectors, and book dealers from Europe and the United States to discuss the origins and legacy of modernism. It published an exhibition catalog that featured essays by writers, artists, and scholars associated with the collections, including Julian Barnes, Russell Banks, David Douglas Duncan, and Penelope Lively.

The ambitious programming schedule has continued apace since the building's reopening. Over the years, the Center has come to sponsor several endowed lectures: the David Douglas Duncan Endowed Lecture in Photojournalism; the Stanley Burnshaw Lecture in literature;

Entrance to the Charles Nelson Prothro
Theater, where lectures, readings, and
other events at the Center take place, 2004.
Copyright Thomas McConnell Photography.

Students enjoy "Poetry on the Plaza"
outside the Ransom Center, 2003.

Beginning with Reginald Griffith's *Alexander Pope: A Biography,* published in 1922 by the University of Texas, there is a long history of celebrated works that resulted from research conducted in the Ransom Center's collections. Among the most notable are:

Collected Letters of George Bernard Shaw, edited by Dan H. Laurence (London: Max Reinhardt, 1965–1988; New York: Dodd, Mead, 1965–1988)

Internationally recognized Shavian scholar Dan H. Laurence consulted the four thousand letters in the Ransom Center's George Bernard Shaw collection for this four-volume work.

The Cambridge Edition of the Letters and Works of D. H. Lawrence (Cambridge, 1979–)

This massive series—including eight volumes of letters and more than thirty volumes of novels, essays, and other works—provides authoritative texts of the writings of this important British writer. The Ransom Center's extensive collection of Lawrence's manuscripts and letters was consulted for many of the books in this series.

Bernard Shaw by Michael Holroyd (London: Chatto and Windus, 1988–1992; New York: Random House, 1988–1992)

Also drawing heavily on the Ransom Center's collection of Shaw materials—which includes manuscripts of 419 works, books from Shaw's personal library, sketches, photographs, financial records, and other items—is Holroyd's monumental six-volume biography.

Anne Sexton: A Biography by Diane Wood Middlebrook (Boston: Houghton Mifflin, 1991)

Middlebrook's controversial and revealing biography, which took a decade to complete and was nominated for the National Book Award, drew extensively on the complete archive of Anne Sexton—comprising hundreds of pages of unpublished poems, as well as manuscripts of her published works, travel notebooks and journals, letters, photographs, and other items—housed at the Ransom Center.

Tom: The Unknown Tennessee Williams by Lyle Leverich (New York: Crown, 1995)

Leverich's biography provides the authoritative account of the early life of Tennessee Williams. Leverich consulted the Ransom Center's voluminous Tennessee Williams archive, which houses manuscripts of more than one thousand works, including his early plays, essays, screenplays, stories, and poems, as well as his correspondence and photographs of his apprentice years.

The Selected Letters of Tennessee Williams, edited by Albert J. Devlin and Nancy M. Tischler (New York: New Directions, 2000)

This two-volume edition of the correspondence of one of America's finest playwrights was based, in part, on the sizable collection of letters in the Ransom Center's Tennessee Williams archive. They reveal Williams to be one of the best and most entertaining American letter writers of the century.

Accomplished biographer and literary historian Stanley Weintraub, one of the most prolific scholars to use the collections, has published more than fifteen books that were based on research he conducted at the Ransom Center. He wrote about the Center in an article for the *Texas Humanist:*

To work at the HRC as a scholar is (to put the experience in food terms) like going to a luxury-class restaurant. The service is personal and superior, the menu enormous and sumptuous. The problem can be a severe case of writer's indigestion if not enough time is allowed to consume the full plate. After all, the HRC has thousands of letters by Dante Gabriel Rossetti, D. H. Lawrence, Lytton Strachey, Evelyn Waugh, and Bernard Shaw; the manuscripts or corrected typescripts of William Faulkner's Absalom! Absalom!, E. M. Forster's A Passage to India, Arthur Miller's Death of a Salesman, Oscar Wilde's Lady Windermere's Fan, T. H. White's The Once and Future King, . . . Dylan Thomas's Under Milkwood, Graham Greene's The Power and the Glory, Aldous Huxley's Brave New World, Somerset Maugham's The Moon and Sixpence. It is hardly possible to write a book on a modern master, English or American (or even French), without touching down at the HRC.[4]

The critically acclaimed exhibition *Make It New: The Rise of Modernism,* mounted in the Ransom Center Galleries, 2003

the Amon G. Carter Foundation Lecture in art; and the Pforzheimer Lecture on the Renaissance, textual studies, and bibliography. In 2002, it initiated "Fridays in Photography," a series of programs held on various Fridays to highlight the photography collections. The Center hosts periodic film series, often in partnership with local theaters or film organizations, to bring attention to films from or related to the collections. Other programs and lectures support exhibitions or celebrate new acquisitions.

Many visitors come to the Ransom Center to attend exhibitions and programs, but it is the collections that bring thousands of researchers from all over the world through the doors. Each year, they publish more than one hundred books, dissertations, and articles that use the Center's holdings as primary source material. To encourage scholarly work among the collections, the Center has built a strong fellowship program, financially supporting the research of nearly fifty scholars each year. In 2005, with support from the Andrew W. Mellon Foundation and other donors, the Center established a $1.5 million endowment to continue its fellowship program in perpetuity, ensuring sustained support for scholarly inquiry.

While the Ransom Center continued to strengthen its exhibitions, fellowships, and programs, it was also reaching audiences in other ways.

The Ransom Center's reading and viewing
room, 2004

Ransom Center staff create digital scans of
every page of the Gutenberg Bible, 2002.

The Center made its catalogs and collection descriptions available on the web, making it considerably easier for patrons to search the collections and plan their research before entering the building. As technology advanced, it became possible to create digital scans of items from the collections and re-create them electronically in startling clarity and resolution. The Ransom Center began its first large-scale digitization project in 2002, when it scanned each of the nearly thirteen hundred pages of its two-volume copy of the Gutenberg Bible. The following year, the digitized Gutenberg Bible was put on the Center's webpage, enabling an audience unimpeded by location, time, and the delicate nature of the physical text to view the entire Bible, page by page. In merely one month, the digitized Gutenberg Bible received more than 14 million online visits. The popularity of the digital Gutenberg Bible inspired further digitization projects and the creation of online exhibitions and webpages that feature digital renderings of collection materials.

COLLECTING IN THE TWENTY-FIRST CENTURY

As the Ransom Center improved accessibility to its holdings, it was, of course, continually adding new collections. In fact, the first years of the twenty-first century featured some of the Center's most celebrated acquisitions.

On April 7, 2003, the University of Texas hosted a press conference to announce that the Ransom Center had acquired the Watergate papers of Bob Woodward and Carl Bernstein, a mass of materials related to their investigative work on the Watergate scandal and the demise of President Richard Nixon. The papers provide a meticulous record of Watergate, from the arraignment of the accused burglars after the break-in at the Democratic National Headquarters to the fallout that coursed through the White House when the full scope of the cover-up was revealed. The collection offers an unparalleled, behind-the-scenes perspective into the nature of investigative journalism, the American political process, and the Nixon presidency. It includes notes, interviews, memos of phone conversations, story drafts, research documents, and all other materials the reporters created and collected for their *Washington Post* reporting and their books *All the President's Men* and *The Final Days*. Aside from its obvious national importance, the collection would prove to be a great source of collaborative and interdisciplinary study at the University, bringing scholars and students from various fields together to research and discuss Watergate.

The acquisition of this important collection would not have been possible without the support of University President Larry Faulkner,

Bob Woodward's first notes on the Watergate scandal, taken at the arraignment of the Watergate burglars, June 17, 1972

who committed to find private funding for the purchase and supported the collection in many ways following its arrival. The University hosted a symposium to celebrate the opening of the papers, inviting Watergate scholars and figures to participate. Programs and symposia have continued on a semiregular basis, encouraging students and scholars to explore this crisis in the presidency and the consequences that continue today. An endowment was established, with contributions from Woodward and Bernstein, to promote these programs and research in the collection.

It is a testament to the Center's international stature that it was offered Woodward and Bernstein's papers, a collection that resides somewhere outside the Center's primary collecting scope. It might have appeared to be an unusual acquisition for the Ransom Center at the time, but the Center took the broad view that Watergate was more than a political scandal; rather, it was one of the defining events of late-twentieth-century American culture. The Center's reputation for first-rate conservation practices, its renowned holdings, and its commitment to public access have helped it draw major collections like the Water-

Watergate personnel diagram, created by Woodward and Bernstein's research assistant Al Kamen while the reporters were researching for their book *The Final Days*, 1974

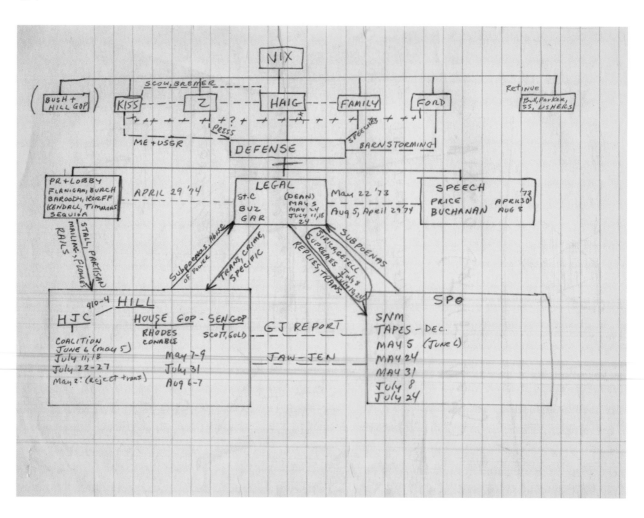

COLLECTING THE IMAGINATION

Panelists, including Bob Woodward, discuss Watergate, Nixon, and the presidency at the symposium "The Legacy of Watergate: Opening the Woodward and Bernstein Papers," 2005.

Former University of Texas President Larry R. Faulkner, Bob Woodward, Carl Bernstein, and Tom Staley, celebrating the opening of the Woodward and Bernstein Watergate Papers at the Ransom Center, 2005

gate papers from individuals who want their materials not only properly cared for but also given life through scholarly use.

In the past decade, the Center has continued to expand its literary holdings, focusing in particular on the works of twentieth-century and contemporary writers. It acquired a small collection of Thomas Pynchon manuscripts, especially valuable because so few Pynchon materials have been made available for research. In 2002, the Center acquired the full archives of contemporary fiction writers Russell Banks and Julian Barnes. Barnes's collection is especially notable because it offers a nearly complete record of his creative process. He wrote of the materials, "Everything I do from the moment I am faced by what I recognize as the possibility—or pre-possibility—of a novel is contained within the archive. I have never thrown away more than the occasional (more or less duplicate) page of typescript. My archive therefore contains 98 or 99% of all the marks I make on paper as a novelist."[7] In 2004, the Center acquired the archive of Don DeLillo, one of the most important American novelists of the last thirty years. The Center celebrated this acquisition with a rare public reading by the author, his first public appearance at a university. Major additions were also made to the collections of works by Tennessee Williams, James Jones, Graham Greene, Evelyn Waugh, Leon Uris, John Fowles, and Arthur Miller, among others.

On April 25, 2005, the Ransom Center again made national headlines with the acquisition of the complete archive of American icon and iconoclast Norman Mailer. Mailer's enormous collection, weighing more than ten tons, spans seventy years of his prolific and distinguished career and contains materials associated with every one of his literary projects. When asked why he chose Texas as a home for his archive, Mailer answered:

"I'd say the major part of my decision (and pleasure) to have this archive go to the Ransom Center is that you have one of the best, if not, indeed, the greatest collection of literary archives to be found in America. What the hell. Since it's going to Texas, let's say one of the best in the world."[8]

Mailer's collection, in all its mass and depth, now resides at the Ransom Center as one of the centerpieces of its twentieth-century holdings. It is a boon to scholars not only because it comprehensively records the career of one of the century's most prominent writers but also because it documents the political, social, and cultural struggles of an entire generation. Mailer visited the Center to celebrate the acquisition, giving a characteristically provocative public lecture. The acquisition and corresponding publicity attracted supplemental materials to the

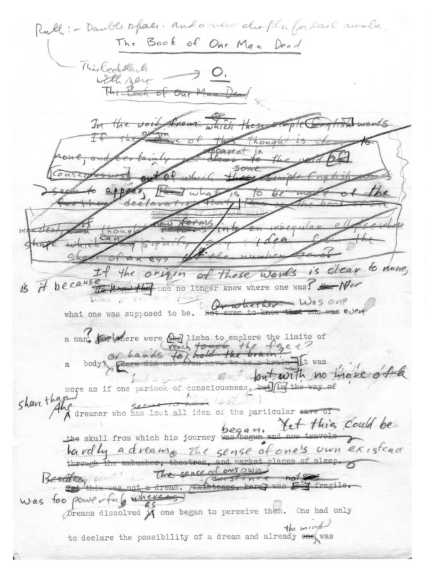

Norman Mailer at the Ransom Center, 2005

Hand-corrected typescript of the opening pages of Norman Mailer's *Ancient Evenings* (1983). Copyright Norman Mailer.

Ransom Center, including a collection of nearly three hundred editions of Mailer's works, recordings of interviews about Mailer conducted by one of his biographers, and other small collections of correspondence, ephemera, and rare materials about or by Mailer. These supplemental collections give researchers a fuller view of Mailer, his work, and his influence on American culture and literature.

Other acquisitions highlighted twentieth-century culture, including the archive of acting teacher Stella Adler. Adler, a major figure in the New York theater scene, founded the famed Stella Adler Conservatory of Acting, where she taught such legends as Marlon Brando, Robert De Niro, Warren Beatty, Peter Bogdanovich, Martin Sheen, and Harvey Keitel. Her collection enhances both the performing arts and film holdings at the Center. Further strengthening the film holdings is the remarkable archive of perhaps Adler's most famous student, Robert De

First edition of Norman Mailer's acclaimed debut novel (1948)

Niro. A gift from De Niro, the collection includes not only the heavily marked scripts and research materials he prepared for each production but also every costume he ever wore. The Center also acquired a rich collection of materials related to the work of Woody Allen.

Strengthening its international collections, the Center acquired additional materials for the Carlton Lake collection of French literature and art in 2002. In 2004, the Center purchased the papers of Commandant Ferdinand Forzinetti, which constitute one of the most extensive collections in existence related to the 1894 trial of Captain Alfred Dreyfus, a Jewish artillery officer in the French army who was wrongly convicted of treason. The Center also acquired the largest collection

A CASE OF THEFT

Recent years have seen a series of major thefts of library materials from collections large and small: maps and autographs from the Beinecke Library at Yale, architectural books from Harvard, rare books from Kenyon College. For the first thirty years of its existence, the Ransom Center was fortunate enough to escape this scourge of special collections. Although there were some relatively small thefts—a first edition of Darwin's *Origin of Species* was taken from the reading room, and notes by Albert Einstein were extracted from a display case—the perpetrators were quickly apprehended and the materials soon recovered.

In the mid-1990s, however, routine inventories of the book collections revealed that certain examples of fine and early printing were suspiciously absent from the Center's shelves. Notices of the missing items were sent out to the book trade. In 2001, the case was cracked wide open with the assistance of booksellers and a librarian at another institution who spotted an extremely rare edition of Petrarch's poems in an auction catalog. This copy, printed by Aldus Manutius on vellum and in a distinctive Italian red morocco binding with ornamented gilt edges, had been listed as missing in the Center's 1998 bibliography of its Aldine collection. Within a few days after the item appeared in the catalog, the FBI was on the case, and the thief was easily identified from auction records: Mimi Meyer, a volunteer in the conservation department between 1989 and 1992 who had since moved to Chicago. Meyer stole approximately $800,000 worth of rare books and had auctioned many of them. Although the criminal case ended with Meyer's 2004 sentencing in Federal Court (she received three years' probation) and the return of some of the books, the recovery process is ongoing and will take many years.

When it first learned of the thefts, the Ransom Center administration took immediate measures to limit access to the collections, and the 2003 renovation incorporated major improvements to electronic security systems. Yet despite the best precautions, thefts continue to plague the world of rare books and manuscripts in what one expert called a "never-ending saga."

The stolen copy of Petrarch's works (printed on vellum by Aldus Manutius in 1514), which was returned to the Ransom Center in 2004

outside Paris of materials related to the works of Raymond Queneau, who is widely considered one of the most original French writers of the twentieth century. To celebrate the acquisition and Queneau's place in the literary canon, the Center hosted an international conference on the writer in 2005.

The momentum from these acquisitions offered fresh opportunities for the Ransom Center. In 2004, the Center launched a capital campaign to raise more than $10 million to support its expanded agenda for collection development, programs, exhibitions, and a strengthened photography collection. The campaign, titled "The Next Chapter: A Vision for the 21st Century," was designed to build the Center's endowments, ensuring that its outreach and collection development efforts would continue to grow, independent of state appropriations. Private support has helped to fund not only important and costly collections such as the Mailer archive and the Watergate papers but also the academic and research priorities of the Center. Generosity from donors and foundations has been essential to the growth of the institution, enabling the Ransom Center, as it transitions into the twenty-first century, to engage visitors more fully with its collections.

THE NEXT CHAPTER

In the fifty years since Harry Ransom first conceived the idea of a humanities research center, the Ransom Center has had a storied existence. Among research libraries, its history has been somewhat legendary—almost mythological—and at times controversial. The myth and controversy are perhaps only greater because it happened rather unexpectedly at a public university in Texas, where things tend to be a bit larger than life, and myth and reality sometimes merge. The Center's growth from modest roots to international stature in only a few decades and its liberal spending on collections are remarkable, though not quite as great as myth would have it.

The Ransom Center owes its beginnings to Harry Ransom's bold vision, but this vision began to take some shape even before Ransom's time in the hands of Fannie Ratchford and Reginald Griffith, and perhaps even with the writers of the Texas Constitution who called for the creation of a "university of the first class." The vision took root under the careful stewardship of Ransom and Warren Roberts and grew stronger under a succession of directors, curators, and librarians.

The history of the Ransom Center is, more than anything else, a story of the collections. They are the foundation from which the Center's mission grows, inspiring the exhibitions, conservation efforts, pro-

grams, publications, cataloging projects, and research commitments for which the Ransom Center has become known. Since the earliest years of the University, when it began slowly to acquire private libraries, to the robust years of collection development under Harry Ransom and Tom Staley, the Center has built a notably diverse cultural record. Where else could the Gutenberg Bible and the First Photograph exist in harmony with Leatherface's mask from *The Texas Chainsaw Massacre*? The Ransom Center's collections reflect the multiplicity that is culture, from Shakespeare's folios to the dresses Vivien Leigh wore as Scarlett O'Hara in *Gone With the Wind*. The Center brings together James Joyce and Norman Mailer, Daguerre and David Douglas Duncan, Dante Gabriel Rossetti and Pablo Picasso. One of the Center's strengths is the diversity of its holdings and its broad view of culture. Through stewardship of these collections, the Ransom Center ensures that the rich materials that trace literary and artistic accomplishments across centuries will be accessible for future generations.

As the Center celebrates its fiftieth anniversary, it looks back on the books read, the manuscripts studied, the dissertations written, and the ideas explored and inspired by its collections. It also reflects on and celebrates the cultural achievements of the past fifty years and looks forward to a future of continued discovery.

NOTES TO TEXT

1. Robert Faires, "Look Back in Wonder: The British Invasion, Part One: Theatre, 1956–1996," *Austin Chronicle,* November 8, 1996.

2. Staley, Introduction to *Shouting in the Evening,* 9.

3. John Sutherland, *The Guardian,* May 5, 2003.

4. "Interview with Thomas F. Staley."

5. Stephen Kinzer, "Lifting the Lid on a Treasure Chest: From Artworks to an Author's Socks at the University of Texas," *New York Times,* February 4, 2003.

6. Christopher Reynolds, "A Library Unlocks Its Attic," *Los Angeles Times,* August 5, 2003.

7. Barnes, unpublished description of his archive, February 22, 2001.

8. "Ransom Center Acquires Norman Mailer Archive," Ransom Center press release, April 25, 2005.

NOTES TO SIDEBARS

1. Staley, "On the Selling of Literary Archives."

2. Arnold Wesker, "There's a Price on My Head," *Sunday Times,* November 5, 2000.

3. Diane Johnson, "The Paper Trail: Writer Takes Letters, Notes and Unfinished Works to Texas," *San Francisco Chronicle,* April 29, 2001, 78, 86.

4. Weintraub, "Humanities Research Center," 6–7.

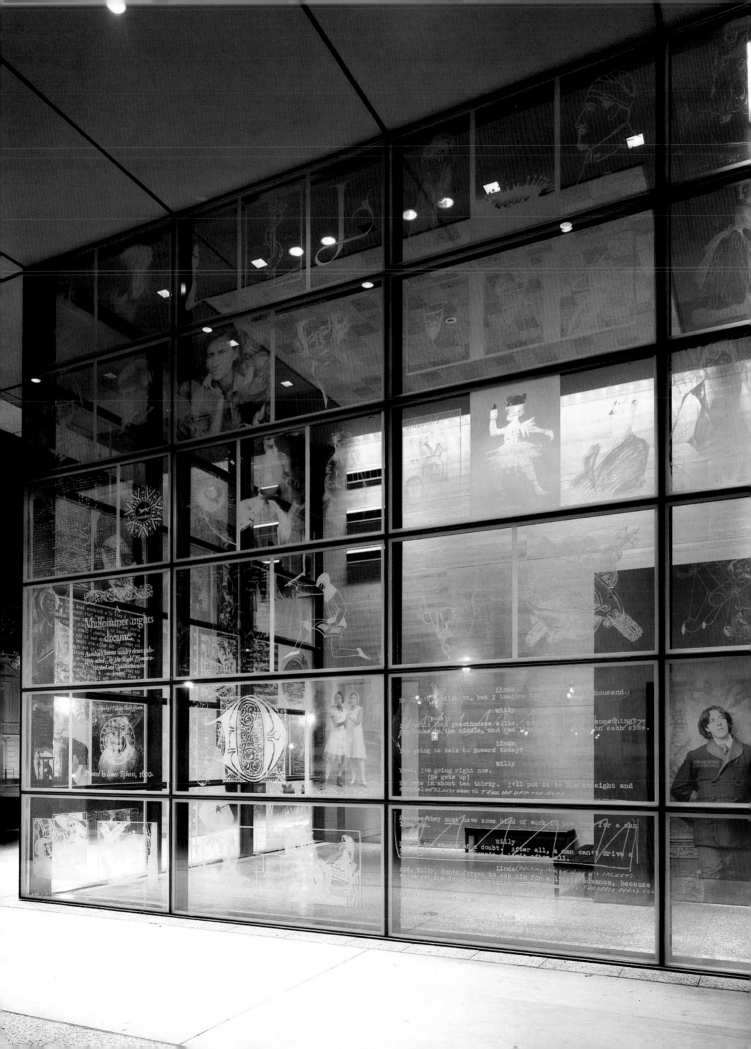

In addition to collection, administrative, and institutional files and publicity scrapbooks at the Harry Ransom Center, and various issues of *The Library Chronicle,* published by the University of Texas, the following materials were consulted for this volume:

Abbott, Charles. Introduction to *Poets at Work: Essays Based on the Modern Poetry Collection at the Lockwood Memorial Library, University of Buffalo,* by Rudolf Arnheim and others, 1–36. New York: Harcourt, Brace, 1948.

Barker, Margaret, ed. *Guide to the Collections.* Austin: Harry Ransom Humanities Research Center, 2003.

Barnes, Julian. Unpublished description of his archive, February 22, 2001.

Basbanes, Nicholas A. *A Gentle Madness: Bibliophiles, Bibliomanes, and the Eternal Passion for Books.* New York: Holt, 1995.

Benjamin, Walter. "The Work of Art in the Age of Mechanical Reproduction." In *Illuminations: Essays and Reflections,* edited by Hannah Arendt, 219–253. New York: Harcourt Brace and World, 1968.

Billings, Harold. "The Woman Who Ran Ransom's University." In *The Texas Book: Profiles, History, and Reminiscences of the University,* edited by Richard Holland. Austin: Center for American History, University of Texas Press, 2006.

Boroff, David. "Cambridge on the Range." *Saturday Review,* June 20, 1964.

Bowden, Edwin T. *The First Hundred Publications of The Humanities Research Center of The University of Texas at Austin.* Austin: Humanities Research Center, 1971.

———. "The Publications of the Humanities Research Center, 1958–1963." *The Library Chronicle* 7, no. 4 (1964): 40–54.

Burns, Joan Simpson. *The Awkward Embrace: The Creative Artist and the Institution in America: An Inquiry Based on Interviews with Nine Men Who Have, through Their Organizations, Worked to Influence American Culture.* New York: Knopf, 1975.

Carter, John, and Graham Pollard. *An Enquiry into the Nature of Certain Nineteenth Century Pamphlets.* London: Constable, 1934.

Cline, Clarence Lee. *Harry Huntt Ransom, 1908–1976.* Austin: University of Texas at Austin, 1983.

Connolly, Cyril. "Introduction to the Exhibit." In *One Hundred Modern Books from England, France and America 1880–1950,* by Mary Hirth, 4–8. Austin: Humanities Research Center, 1971.

Díaz del Castillo, Bernal. *Historia verdadera de la conquista de la Nueva España.* Madrid: Impr. del Reyno, 1632.

Dictionary of Literary Biography. American Book Collectors and Bibliographers, Series II. Detroit: Gale, 1998; s.v. "Harry Ransom," 247–255.

Dictionary of Literary Biography. American Book Collectors and Bibliographers, Series I. Detroit: Gale, 1994; s.v. "John Henry Wrenn," 319–326.

Dunlap, Ellen S., Cathy Henderson, and Sally Leach. *The Finest Adventure: Scholars at Work.* Austin: Humanities Research Center, 1983.

Gioia, Dana. *Disappearing Ink: Poetry at the End of Print Culture.* St. Paul, Minn.: Graywolf Press, 2004.

Goldbarth, Albert. "Hunt." In *Arts & Sciences: Poems,* 24–34. Ontario Review Press, 1986.

Gribben, Alan. "Intellect in Motion: The Life of Harry Huntt Ransom." Unpublished, 1998.

Griffith, Reginald Harvey. *Alexander Pope, a Biography.* University of Texas Studies in English. London: Holland Press, 1962.

A Guide to the Harry Ransom Humanities Research Center. Austin: Harry Ransom Humanities Research Center, 1990.

Hamilton, Charles. *Auction Madness: An Uncensored Look Behind the Velvet Drapes of the Great Auction Houses.* New York: Everest House, 1981.

The Handbook of Texas Online. Austin: The University of Texas General Libraries and the Texas State Historical Association, http://www.tsha.utexas.edu/handbook /online/

Hobson, Anthony. *Great Libraries.* New York: Putnam, 1970.

"In Memoriam: Harry Huntt Ransom." *The Texas Quarterly* 19, no. 4 (1976): 165–184.

"Interview with Thomas F. Staley." *Dictionary of Literary Biography Yearbook 2000.* Detroit: Bruccoli Clark Layman/Gale, 2001.

Kazin, Alfred. *On Native Grounds: An Interpretation of Modern American Prose Literature.* New York: Reynal and Hitchcock, 1942.

Lake, Carlton. *Baudelaire to Beckett: A Century of French Art & Literature: A Catalogue of Books, Manuscripts, and Related Material Drawn from the Collections of the Humanities Research Center.* Austin: Humanities Research Center, The University of Texas, 1976.

———. *Confessions of a Literary Archaeologist.* New York: New Directions, 1990.

Larkin, Philip. "A Neglected Responsibility: Contemporary Literary Manuscripts." In *Required Writing: Miscellaneous Pieces 1955–1982,* 98–108. New York: Farrar, Straus, Giroux, 1983.

Laurence, Dan. Foreword to *Shaw: An Exhibit.* Austin: Humanities Research Center, 1977.

The Library Chronicle 4, no. 1 (1950): 55.

Lowman, Al. *Printing Arts in Texas.* Austin: R. Beacham, 1975.

Lyons, Gene. "The Last of the Big-Time Spenders." *Texas Monthly,* January 1978, online at http://www.texasmonthly.com/mag/issues /1978-01-01/feature.php

McNutt, Gayle. "England's Literary Best: UT Raids Treasure Trove." *The Houston Post,* February 6, 1966.

Norcross, Frederic Franklin. *John H. Wrenn and His Library; Notes and Memories.* Chicago: R. R. Donnelley, 1933.

Norton, Ingrid. "Book Festival Kicks Off at HRC." *Daily Texan,* October 28, 2005.

Oram, Richard W. "'Going towards a Great Library at Texas': Harry Ransom's Acquisition of the T. E. Hanley Collection." In *The Texas Book: Profiles, History, and Reminiscences of the University,* edited by Richard Holland. Austin: Center for American History, University of Texas Press, 2006.

"Ransom Center Acquires Norman Mailer Archive." Ransom Center press release, April 25, 2005.

Ransom, Harry H. "The Academic Center: A Plan for an Undergraduate Library." *The Library Chronicle* 6, no. 4 (1960): 48–50.

Ransom, Hazel, ed. *Chronicles of Opinion: On Higher Education, 1955–1975.* Austin: University of Texas at Austin, 1990.

Ratchford, Fannie, ed. *Between the Lines; Letters and Memoranda Interchanged by H. Buxton Forman and Thomas J. Wise.* Austin: University of Texas Press, 1945.

———. *The Brontës' Web of Childhood.* New York: Columbia University Press, 1941.

———. *Legends of Angria; Compiled from the Early Writings of Charlotte Brontë.* With William Clyde DeVane. New Haven: Yale University Press, 1933.

———, ed. *Letters of Thomas J. Wise to John Henry Wrenn: A Further Inquiry into the Guilt of Certain Nineteenth-Century Forgers.* New York: Knopf, 1944.

———, ed. *Two Poems; Love's Rebuke; Remembrance,* by Emily Brontë. Austin: Early Martin Press, 1934.

Roberts, Warren. Introduction to *A Creative Century; Selections from the Twentieth Century Collections at the University of Texas.* Austin: Humanities Research Center, 1964.

———. *Twentieth-Century Research Materials; a Decade of Library Development and Utilization.* Austin: Humanities Research Center, 1972.

Ross, Noreen. "Perry Mason Was Born Here!" *Kaleidoscope El Paso Magazine* (April 1973): 10–11.

Rota, Anthony. *Books in the Blood: Memoirs of a Fourth Generation Bookseller.* New Castle, Del.: Oak Knoll Press, 2002.

Sitter, Clara Marie Loewen. "The History and Development of the Rare Books Collections of The University of Texas Based on Recollections of Miss Fannie Ratchford." Master's thesis, University of Texas, 1966.

Staley, Thomas F. Introduction to *Shouting in the Evening: The British Theater 1956–1996,* edited by Cathy Henderson and Dave Oliphant, 9–13. Austin: Harry Ransom Humanities Research Center, 1996.

———. "Literary Canons, Literary Studies, and Library Collections: A Retrospective on Collecting Twentieth-Century Writers." *Rare Books and Manuscripts Librarianship* 5, no. 1 (1990): 9–21.

———. "On the Selling of Literary Archives." *The Author* (Spring 1993).

Nelda C. and H. J. Lutcher Stark Foundation Archives. Orange, Texas.

Todd, William B. *Remembrance of Things Past; or, Various Escapades in the Harry Ransom Humanities Research Center, 1958–1998: The Annual Carl and Lily Pforzheimer Foundation Lecture.* Austin: Harry Ransom Humanities Research Center, 1999.

Turner, Decherd. "The First 25 Years at the HRC." *Alcalde,* May/June 1982, 26.

University News and Information Service press release, July 2, 1960.

U.T. Record 3, no. 4 (1958): 1–3.

Weintraub, Stanley. "Humanities Research Center: A Consumer's Report." *The Texas Humanist* 5, no. 5 (1983): 6–7.

Lundell, Mrs. C. L., 48, 61
Lundell Botanical Library, 38, 48, 61
Lutcher, Henry, 7
Lutcher and Moore, 7
Lyndon Baines Johnson Presidential Library, *2*, 104
Lyon, Danny, 61

Mackenzie, Compton, 54, *54*
MacNeice, Louis, 30
Maguire, Jack, 22
Mailer, Norman, 112–113, *113*, *114*, 116, 117
Main Building, 11, 26
Make it New: The Rise of Modernism exhibition, 104, *107*
Malamud, Bernard, 93
Malraux, André-Georges, 84
Marcus, Stanley, 24, 93
Marius-Michel, Henri, artist's binding, *72*
Masters, Edgar Lee, 59
Matisse, Henri, 57; *Jazz*, ix, 71
Matthiessen, Peter, 92
Maugham, Somerset, 70; *The Moon and Sixpence*, 106
Maverick, Maury, 24
Maximilian (emperor of Mexico), *59*, 60
May, Robert, 88
McCullers, Carson, 59
McLellan, C. S., 14
McMurtry, Larry, 86
McNally, Terrence, 93
Mellon (Andrew W.) Foundation, 96, 107
Melton, Jeff, 103
Mercator globe, *55*
Merchant of Venice (Shakespeare), *79*
Meriwether, James S., 25, 34
Meyer, Mimi, 115
Michener, James, 52
Michener, Mari, 52
Middlebrook, Diane Wood, 64; *Anne Sexton*, 106
Middleton, Harry, 104
Miller, Arthur, 91, 93, 112; *Death of a Salesman*, 106
Milton, John, *Comus*, 78–79
Minoff, Lee, 46–47
Minter, Merton, 24
Mitchell, Margaret, 76
Moll, June, 26
Montaigne, Michel Eyquem de, 71
Moon and Sixpence, The (Maugham), 106
Moore, Marianne, *35*
Morley, Christopher, 33

Morris, William, 71
Morrison, Toni, 88
Muir, Percy, 43
Muray, Nicholas, 70
Murphy, Sue, 103
music collection, 57, 58, 73, *74*, 93

Naked and the Dead, The (Mailer), *114*
National Endowment for the Humanities, 96
Necessity of Atheism, The (Shelley), 14
Neugeboren, Jay, 93
Newberry Library, 75
Newhall, Beaumont, 36
New York World's Fair (1939), 31
Niépce, Joseph Nicéphore, First Photograph, 36, 61, 99, 101, *101*, 117
Nixon, Pat, *2*
Nixon, Richard, 109
Norman (Haskell F.) Collection, 38

Obregón, Álvaro, 5
oil, on University of Texas land, 1, 3
Oliver Twist, illustration of, *xviii*
Oloff de Wet, Hugh, 30, 70
Once and Future King, The (White), 106
Oneal, Cora Maud, 48
Oneal (Cora Maud) Room, 48
One Hundred Modern Books exhibition, 58
O'Neill, Eugene, 91
Opera (Virgil), *69*
Oram, Richard, xii, *73*, 88, 103
Origin of Species (Darwin), 115
Osborne, John, 90; *Look Back in Anger*, 91

Painter, T. S., 21
Palm, Swante, 1, 3
Parsons, Edward Alexander, 21, 28, *29*, 30, 80
Parsons, Mrs. Edward Alexander, *29*
Parsons collection, 28, 30, 69, 80
Passage to India, A (Forster), 33, 106
Payne, John, *54*, 64
Payne, Leonidas W., 12
Peale, Charles Willson, 6
Percy, Walker, 88
performing arts, 32, 37, 51, 58, 89, 90, 91–92, 93, 113
Permanent University Fund (PUF), 3
Perot, H. Ross, 78
Perry Mason, 48
Petrarch, 69, 115, *115*
Pforzheimer, Carl H., 61, 63, 78, 80

Pforzheimer (Carl and Lilly) Foundation, 63, 78
Pforzheimer (Carl) Library of Early English Literature, ix, 21–22, 61, 69, 76, 78–79, 80, 81
Pforzheimer Lecture on the Renaissance, textual studies, and bibliography, 107
Philosophical Society of Texas: founding of, xx; purpose of, xv, xvi; Ransom's speech to, x, xv-xxiii, 23
photography collections: and archives, 61, 93–94; and exhibitions, 61; funding for, 116; history of photography, 36, 37, 61, 64, 73–74, 99, 101; programs highlighting, 107; researchers' use of, 58
Picasso, Pablo, *xviii*, 57, 71, 93, *93*, 99, 117
Pil to Purge Melancholie (pamphlet), 79
Plato, 69
playwrights, 89, 90, 91–92, 93
Plunkett, Walter, 76
Poe, Edgar Allen, 12
"Poetry on the Plaza" program, *100*, 104, *105*
Pollard, Graham, 9, 11
Poor Heretic (Hopkins), 39
Pope, Alexander, 6, 9
portrait busts, 70, *70*
Portrait of George Gershwin in a Concert Hall (Siqueiros), 70, *70*
Possession (Byatt), 95
Pound, Ezra, 30, 35, 64
Powell, Lawrence Clark, 16
Power and the Glory, The (Greene), 106
Powys, John Cowper, 35
Powys, Llewelyn, 35
Powys, Theodore Francis, 35
Powys family manuscripts, 35, 59
Printing Arts in Texas (Lowman), 40
Prothro (Charles Nelson) Theater, entrance to, *105*
Proust, Marcel, 57; *A l'ombre des jeunes filles en fleur*, 58
Ptolemy Philadelphus (king of Alexandria), xvii
publications program, 39–40, 86
public programs, 103–104, 107, 109
Pynchon, Thomas, 112

Queneau, Raymond, 116

Ransom, Harry Huntt: and academic status for Rare Books Collection, 21;

ABOUT THE CONTRIBUTORS

Megan Barnard is Assistant to the Director at the Harry Ransom Center.

Cathy Henderson is Associate Director for Exhibitions and Education and Fleur Cowles Executive Curator at the Harry Ransom Center.

Richard W. Oram is Associate Director and Hobby Foundation Librarian at the Harry Ransom Center.

Harry Huntt Ransom was the founder of the Humanities Research Center, later named the Harry Ransom Center. He was Professor of English at the University of Texas, where he also served as president and eventually as chancellor of the University System.

Thomas F. Staley is Director of the Harry Ransom Center at the University of Texas, where he is also Professor of English and holds the Harry Huntt Ransom Chair in Liberal Arts.

John B. Thomas, III, is Curator of the Pforzheimer Collection at the Harry Ransom Center.